Step-by-Step
MANGA

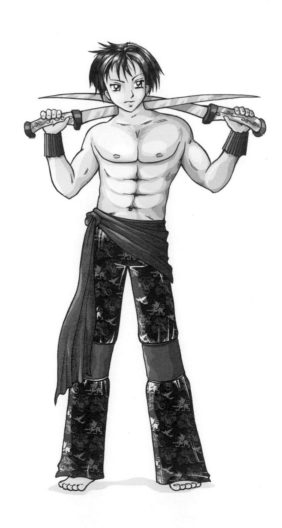

Glossary

ACCESSORIES

A collective term for decorative fashion extras such as hair clips, brooches, hats or belts.

ANIME

The term comes from the English word animation, and has two different meanings. Outside Japan it refers to all animated films produced in Japan. In Japan itself, it encompasses all types of animated films, including those that are not from Japan.

ANTHRO

A specific form of design in which human and animal elements are combined in a character.

BISHIE (SING.)

(Short for bishonen)
These popular male manga characters are slender, sensitive and fashion-conscious, and provide a strong contrast to rougher characters. A bishie embodies the ideal of a Japanese adolescent.

CHIBI (SING.)

Childlike manga characters with particularly large heads and faces. Their large heads are great for expressing emotions effectively.

FINELINERS

Felt-tip pens with a very fine tip. They are great for drawing, writing and sketching, and they come in many colours. Manga artists often use them as an alternative to dip pens.

GENRE

Thematic categories in literature, film, art and music that do not have precise boundaries, such as psychological thriller and crime.

LAYOUT

The artistic arrangement of various graphic elements on a page, spread, website or throughout an entire book.

MARKERS

Felt-tip pens that are well-suited to hand colouring manga drawings. They come in many colours and with different sizes of tip.

MANGA

The word manga literally means grotesque drawing, and the artist Katsushika Hokusai first used the term in the early 19th century. In modern Japan, the word manga simply means comic. In the rest of the world, it is associated with the typical Japanese art style.

MANGAKA

Mangakas are professional manga artists who work for publishers or magazines. The suffix -ka means creator or maker. In Japan, mangakas have pop-star status.

SCREENTONE

Particular graphic textures are printed on adhesive film, which can then be applied to add shading to a line drawing. Digital versions are also available in drawing programs.

SHONEN (PLUR.)

Japanese manga comics that mostly focus on action, monsters, creatures and mysteries. Occasionally, real-life situations are also the subject. Schoolchildren often transform into superheroes with supernatural powers. The harsh world of shonen stands in contrast to the softer world of bishonen (bishie).

SHOJO (SING.)

(Short for bishojo)
Shojo means girl in Japanese. Shojo manga often revolves around the theme of being in love. The stories of these slim and strikingly beautiful girls appeal to girls and boys all over the world. Shojos embody the Japanese ideal of an adolescent.

STORY, PLOT, SCRIPT

In telling a story, there is a distinction between the story, plot and script. While the story is the idea behind the narrative, the plot describes in detail how it unfolds. The plot often serves as the basis for thumbnails and speech bubble texts. The script encompasses the complete text, including descriptions of scenes and emotions.

THUMBNAILS

Small sketches used to quickly illustrate story sequences and make rough divisions for image sizes and text amounts.

Step-by-Step
MANGA

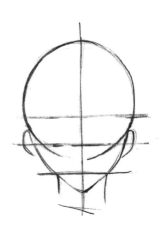
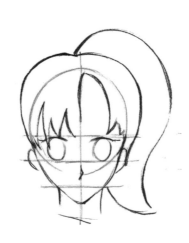

Gecko Keck

SEARCH PRESS

Contents

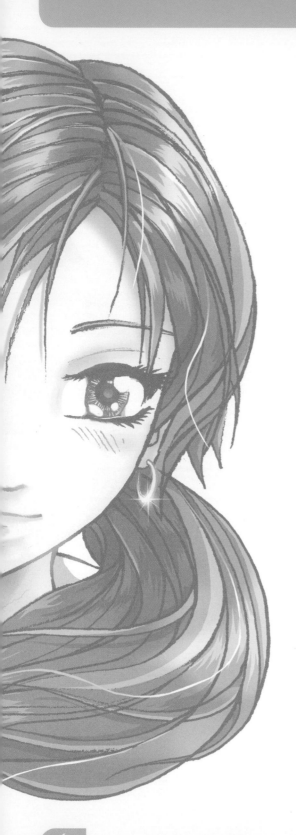

Introduction

It all started decades ago, when the Japanese comic art form known as manga became popular worldwide. Anyone who thought it was a passing fad was very much mistaken. Instead, the art form has grown and developed in style, with trends varying from country to country, and new creative ideas being brought to the fore.

Youth cultures have been inspired by manga, with elements of the art form reflected in today's fashions and make-up, while the influence of manga on modern animated films is clear.

Today, manga is a global phenomenon, and it is no exaggeration to speak of it as an era of art and design with no end in sight. There are always new inspirations and creations, and the number of manga fans is growing relentlessly.

Even the great art galleries in the biggest cities in the world have embraced the genre with exhibitions dedicated to popular manga artists.

If you are new to manga, this book will teach you how to draw in this distinctive style. If this isn't your first time drawing manga characters, then the following pages will inspire you to develop your artistry in new and exciting ways. You will find practical advice and examples of the different manga styles, including shojos, bishies, cute chibis, shonen and many more. The most important piece of advice, however, is to have fun drawing, because to be a proper mangaka, you need to draw as much as possible.

Gecko Keck

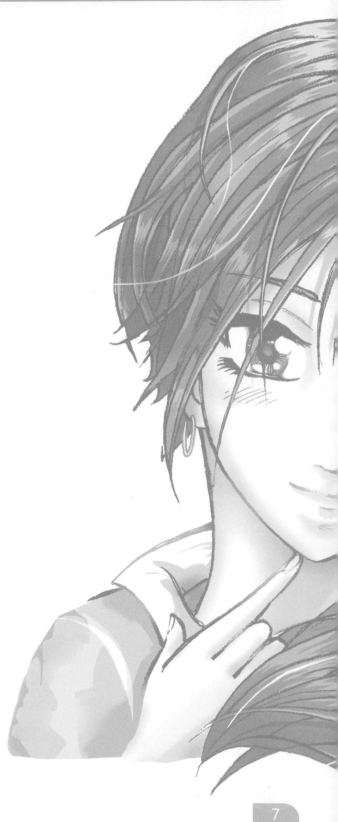

Manga basics

Professional mangakas use specific techniques to give their characters an irresistible, unique look. Once you know how to do it, you'll be amazed at how lively and real your characters look, right from the start.

In this chapter you will learn how to properly construct a manga character and give it life. Graphically, that means understanding the most important elements of manga style and how to render them. You will also learn how to draw movement and show emotion in your characters.

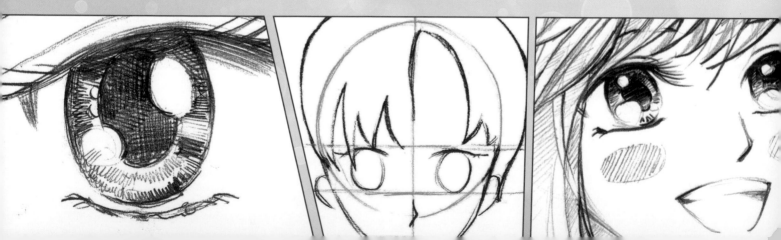

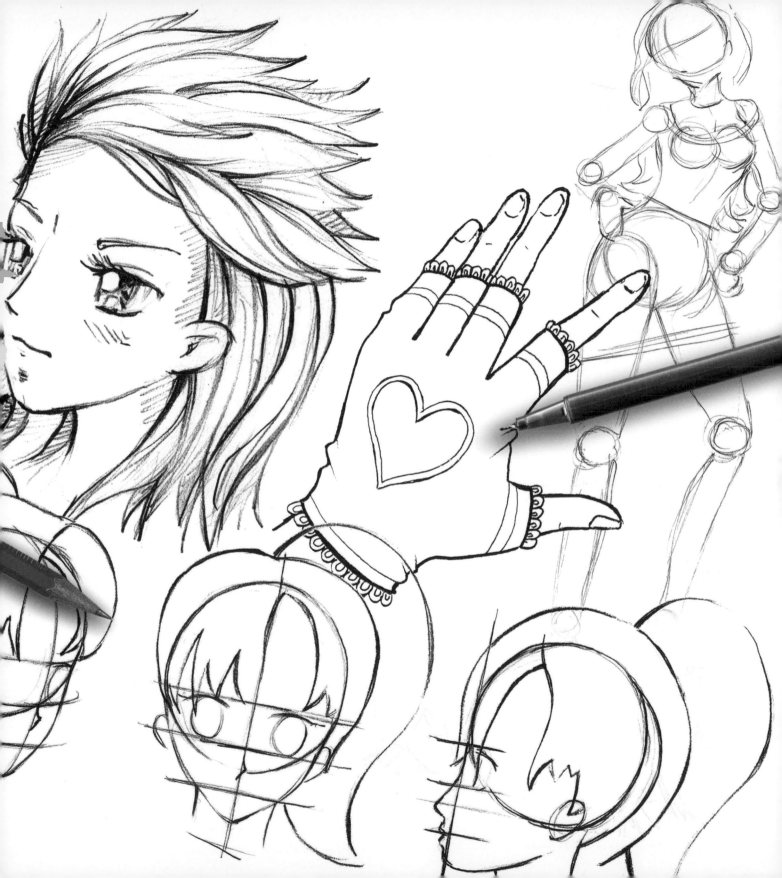

Materials – not just for professionals

In order to create great drawings, you need to use good tools, so choose your pens, pencils and other equipment carefully. Every artist has their preferred brands or types of equipment, and finding your favourite work materials is the first step to developing your own style. However, when you don't have lots of money to spend on art materials, it is good to know which tools are essential, and which are nice extras.

BASIC CHECKLIST

These are your must-have materials. You may already have some of them at home, and the ones you don't already have are not too expensive to buy.

» Pencils of various grades of hardness
» White paper
» Eraser
» Black felt-tip pens in various nib sizes
» Black fineliner
» Ruler
» Firm, smooth surface on which to tape paper and draw

BASIC CHECKLIST PLUS

These items are useful to have. They will make your drawing process easier and allow you to take your characters to another level. We will discuss these tools later in the book.

» Coloured pens and markers
» Artist's lay figure (mannequin)
» Pair of compasses
» White cartridge paper
» Ink pen or brush
» Screentone
» Computer with enough RAM for graphics work
» Scanner and printer
» At least one good graphics program

PROFESSIONAL CHECKLIST

Once you've worked extensively in manga, you may choose to invest in these extra tools.

» Light box
» Curve templates
» Professional graphics program
» Digital fonts packages
» Drawing tablet
» Polythene film

Good to know

There are immense differences in the quality of working materials, and economizing is not usually worth it. Cheap pencils, for example, may break easily, and a fineliner bought on a budget is likely to dry out sooner than a better-quality, more expensive version.

It is a good idea to test out materials to find which ones suit you and which ones you probably won't use. This manga eye has been drawn with different pens and pencils to illustrate their various qualities. You could try a similar exercise for yourself.

Try it!

SOFT PENCIL

Soft pencils, ranging from grade 2B to 6B, are good for drawing dark lines and hatching.

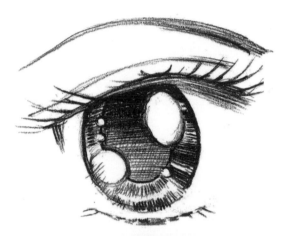

HARD PENCIL

Hard pencils, ranging from grade 2H to 6H, work well for light lines and hatching.

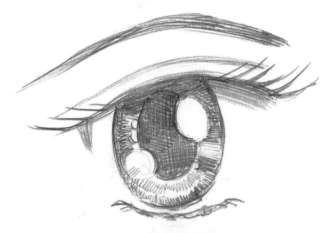

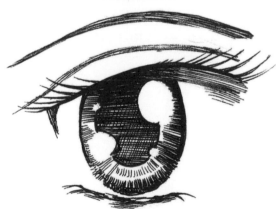

FINELINER

You can draw very fine lines with a fineliner, which is a very thin felt-tipped pen.

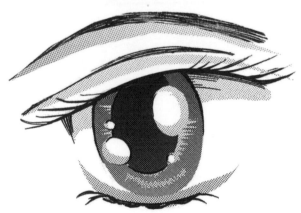

FINELINER AND SCREENTONE

This eye was drawn with a fineliner then filled in with screentone.

Outlines and hatching

Outlines, in black or other colours, are an important stylistic element of manga art. They demarcate the character in relation to the surrounding space, and give the drawing a recognizable manga look. Hatching goes inside the outlines to bring a sense of three-dimensionality.

Pencil outlines and hatching understandably look very different from pen lines, and if you experiment with your equipment, you will immediately notice the different qualities that can be achieved.

Good to know

Drawing good outlines is an art in itself. If your outlines don't look the way you want at first, don't lose heart. With practice they will soon improve, and you will develop your own drawing style.

Detail

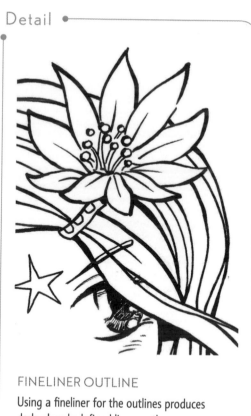

FINELINER OUTLINE

Using a fineliner for the outlines produces dark, sharply defined lines on the paper. Remember that fineliner cannot be erased.

Detail

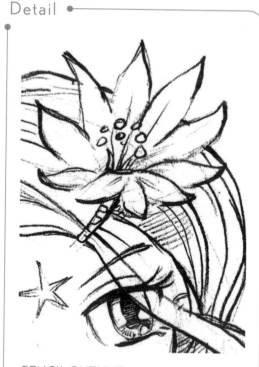

PENCIL OUTLINE

In contrast to fineliner, lines drawn using a pencil are soft and less sharp. Pencil lines can be erased, so if you are not too confident of your drawing skills, pencil is probably a good choice.

COMPARING OUTLINES

These details from a character drawing show the difference in line quality achieved with fineliner and pencil respectively. The fineliner produces a very graphic finish, while using pencil gives the drawing a sketched look, which might be a style you prefer or that suits a particular character.

Hatching is a basic drawing technique that helps characters appear more three-dimensional, and can be used to depict light and shade. When drawing manga, hatching is often employed during first pencil drafts or on storyboards. Later on, in the final drawing, the grey areas or colour gradations will be created using other techniques with a fineliner or ink, as you will see later in the book.

This enlarged example shows the pupil of an eye filled in with pencil hatching.

This example shows the pupil of an eye filled in with fineliner hatching.

3H pencil 3B pencil Fineliner

PARALLEL HATCHING

With this technique, repeated lines are drawn running parallel to each other. In order to achieve the impression of a uniform grey area, the distances between the fine lines should be as equal as possible.

CROSS-HATCHING

As with parallel hatching, lines are drawn parallel to each other. Then, to achieve even finer gradations, a second set of hatching lines is drawn offset and perpendicular to the first hatching.

FORM LINES

These lines run parallel to each other and follow the form of the object being drawn, in this case a curved shape. This type of hatching brings a high degree of three-dimensionality to a drawing.

Starting with the head

One of the reasons why manga is so popular outside Japan could be due to the particularly expressive faces of the mostly young manga heroes. The faces of the characters reflect the feelings of a whole generation. Joy and sorrow, love, adventure and passion – everything is depicted with just a few strokes.

 Hair and eyes play a particularly important role in creating manga characters, which we will explore further later in the book. For now, though, the best thing you can do is to grab your pencil and paper and draw along.

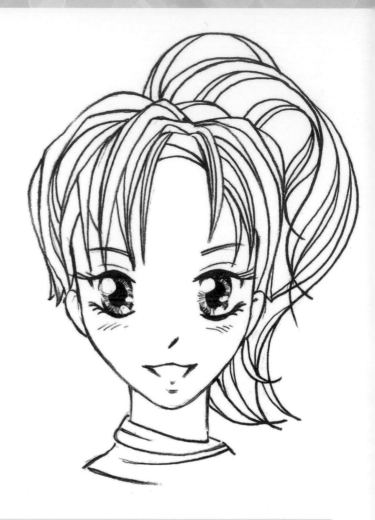

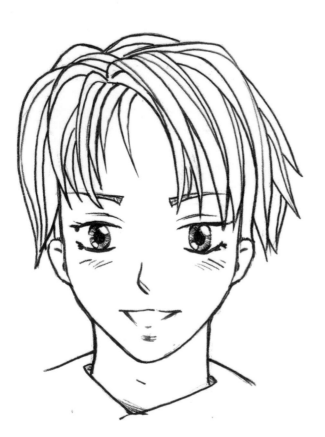

Good to know

The foundations of drawing lie in simple geometric forms, such as triangles, circles or rectangles. You will see these basic shapes time and again when constructing the designs in this book.

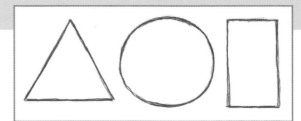

Details

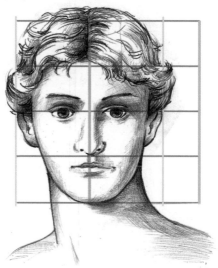

IN REALITY

In order to understand what it means to draw a manga head, it makes sense to start by looking at the anatomy of a real head. This drawn example illustrates ideal proportions. The face is divided into four segments, with the eyes lying exactly on the central horizontal axis and the mouth in the lower quarter.

This short detour into the world of human anatomy establishes one thing: in drawing manga, the laws of nature are set aside in order to achieve the maximum expressive effect. Eyes can become very large and shining, hair can be drawn as flame-like, pointed shapes, and noses and mouths can contract to tiny dots. The specific stylistic elements vary depending on which manga style you choose.

The images below show three of the main styles:

» Left: Chibi girl with typically large eyes
» Centre: A shojo girl also has large eyes but looks more grown-up than the chibi girl
» Right: Typical teen girl found in manga stories

The larger the eyes and the farther down the face they stretch, the younger the character will look. The blue and orange lines illustrate this well.

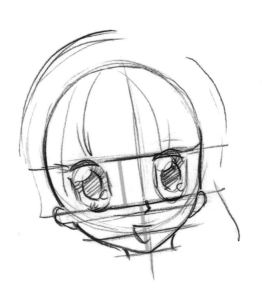

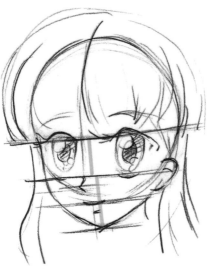

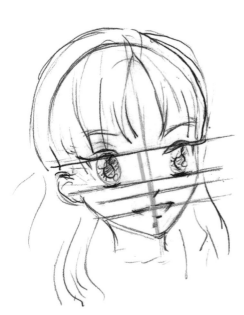

Characteristics of a girl's head

Teenage girls are the heroes of many popular manga stories. Let's take a characteristic head from this age group to show the basic drawing structure from the front, in profile and at an angle. We will then draw the face step by step.

ANGLED FRONT PROFILE

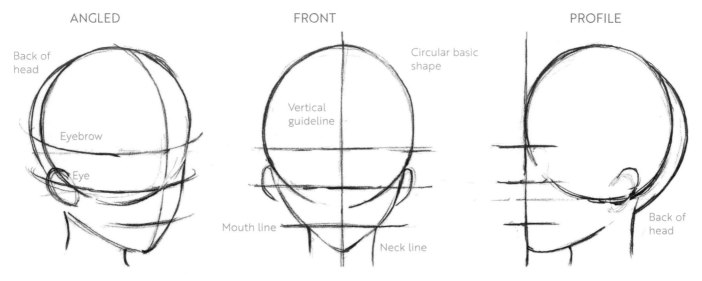

Back of head

Eyebrow

Eye

Circular basic shape

Vertical guideline

Mouth line

Neck line

Back of head

FIRST STEP: The head is constructed from a circle, with a tapering pointed chin shape and guidelines added for the eyes, mouth and nose. The angled head position is the most difficult to draw because the guidelines must be curved accordingly.

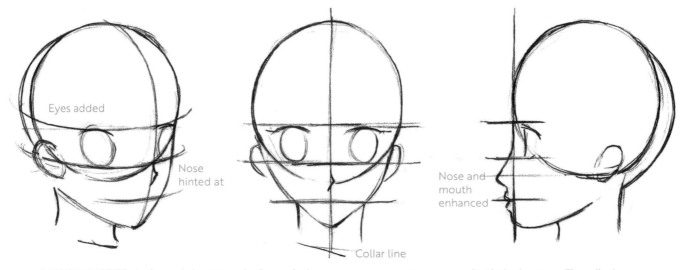

Eyes added

Nose hinted at

Collar line

Nose and mouth enhanced

SECOND STEP: In the angled position, the far eye looks narrower in perspective compared with the front eye. The collar line is hinted at in the front view. The construction is enhanced in profile around the outside of the eyes, and through the shaping of the nose and mouth.

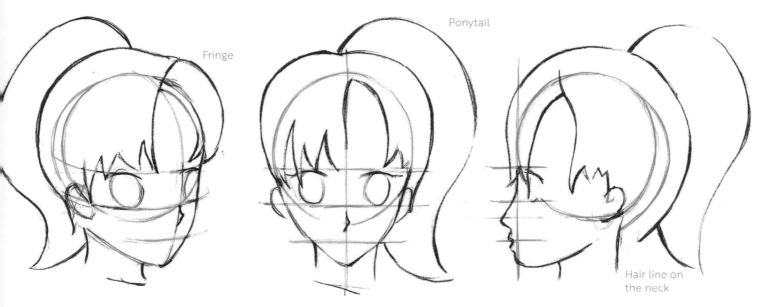

Fringe

Ponytail

Hair line on the neck

THIRD STEP: Manga characters often have big hairstyles. Draw the overall shape of the hairstyle. The blue lines are the guidelines and will either be drawn over or erased.

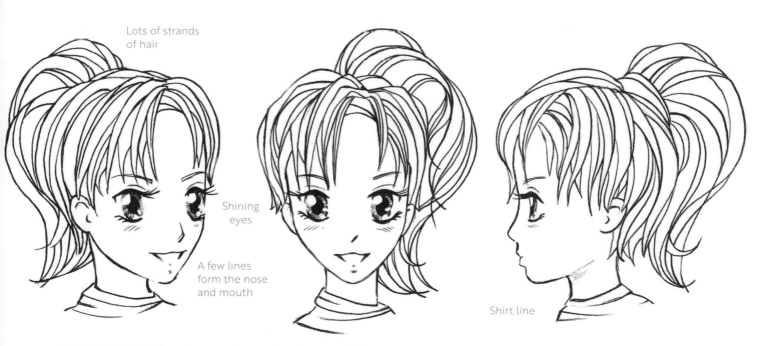

Lots of strands of hair

Shining eyes

A few lines form the nose and mouth

Shirt line

FOURTH STEP: The outlines are drawn in sharply using a fineliner or a soft pencil. Develop the eyes, mouth and nose and fill out the hair with lots of fine strands. The white highlights in the eyes are very important.

Characteristics of a boy's head

Secret or forbidden love, friendship and extreme feelings are popular manga themes, so you will need to be able to draw boys as well as girls. Often the boys are rather androgenous – which means they are quite feminine – but there are a few distinctive differences to notice between drawing boys and drawing girls.

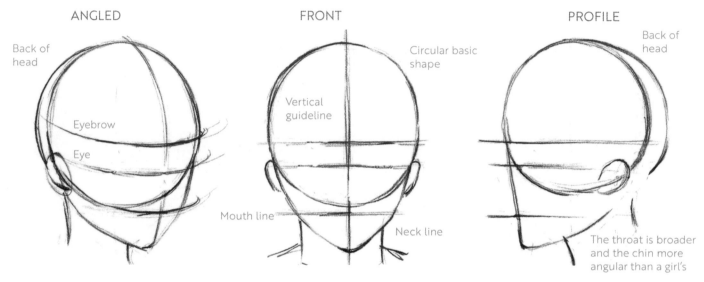

ANGLED

Back of head

Eyebrow

Eye

FRONT

Circular basic shape

Vertical guideline

Mouth line

Neck line

PROFILE

Back of head

The throat is broader and the chin more angular than a girl's

FIRST STEP: The head is constructed from a circle, with a chin added (more pointed than a girl's chin) and guidelines put in place for the eyes, mouth and nose. In the angled position, the guidelines are curved according to the shape of the head.

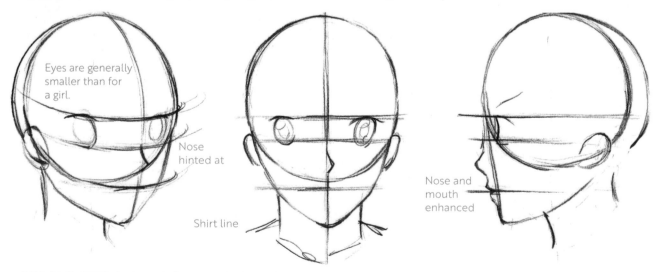

Eyes are generally smaller than for a girl.

Nose hinted at

Shirt line

Nose and mouth enhanced

SECOND STEP: In the angled position, the far eye looks narrower in perspective compared with the front eye. The boy's eyes are a little smaller than a girl's, so the distance between the eye guidelines is also narrower. The shirt line is hinted at in the front view.

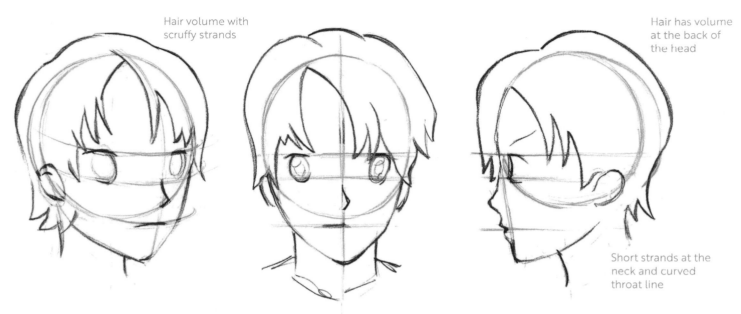

Hair volume with scruffy strands

Hair has volume at the back of the head

Short strands at the neck and curved throat line

THIRD STEP: Boys generally have much shorter hair than girls, and rarely wear accessories. Draw the general shape of the hairstyle before adding individual strands of hair.

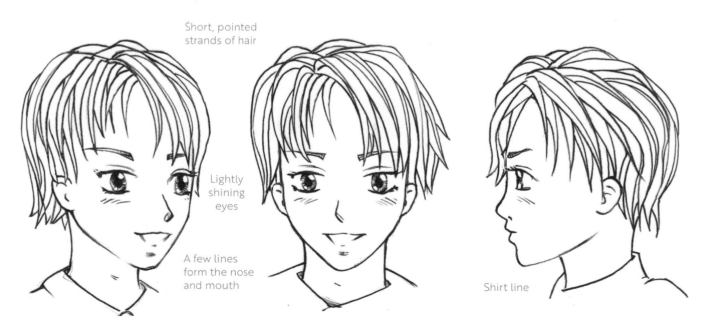

Short, pointed strands of hair

Lightly shining eyes

A few lines form the nose and mouth

Shirt line

FOURTH STEP: Once the basic structure is there, you can draw over the outlines with a fineliner or a soft pencil. Develop the eyes, mouth and nose and fill out the hair with lots of fine strands.

Differing perspectives

Once you have a good grasp of how to draw characters' faces in the three front-facing positions, you can learn how to draw heads from a bird's-eye and a worm's-eye view. From a worm's-eye view, you are looking up from below, whereas from a bird's-eye view, you are looking down from above. Drawing these perspectives requires some skill, but you can do it with the help of a few guidelines and a bit of practice.

Circle basic shape

Sharply curving guidelines for the eyes

FIRST STEP

Start with a circle, but notice that the perspective of the chin will be distorted. The guidelines for the eyes are sharply curved, downwards or upwards, depending on the view.

Vertical guideline

Stretched chin

Sharply curving guidelines for the eyes

High ponytail

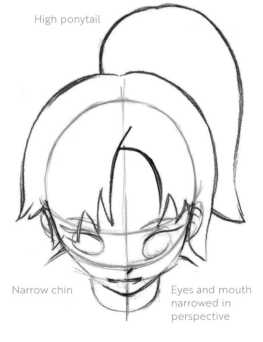

Narrow chin

Eyes and mouth narrowed in perspective

SECOND STEP

Now the eyes, hair and mouth can be drawn in. Take care to account for the perspective distortion. For example, the eyes and mouth will become narrower.

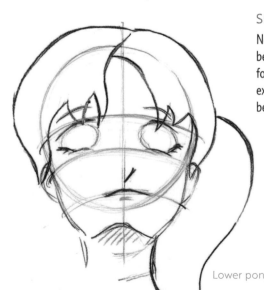

Lower ponytail

BIRD'S-EYE VIEW

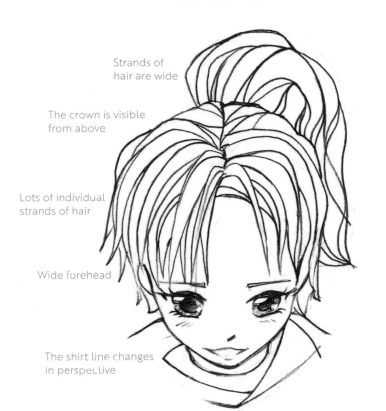

Strands of hair are wide

The crown is visible from above

Lots of individual strands of hair

Wide forehead

The shirt line changes in perspective

WORM'S-EYE VIEW

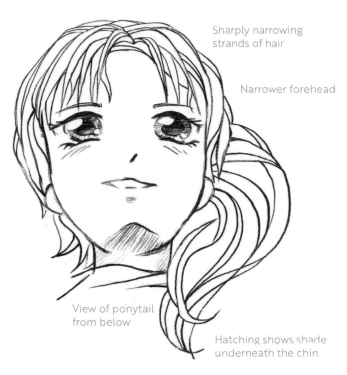

Sharply narrowing strands of hair

Narrower forehead

View of ponytail from below

Hatching shows shade underneath the chin

THIRD STEP

Once the basic construction of the head is correctly established in perspective, it is easier to fill out the details and draw over the outlines. However, there are a few important aspects to keep in mind: the strands of hair change with perspective, becoming narrower or wider depending on the viewpoint. The same applies to the neckline of the clothing.

Good to know

Drawing characters from different viewpoints is challenging, and might cause you to doubt your skills. There are tricks, however, that can help you. For example, using photographs is a great way to study how perspective affects what you see. You can either take a quick photo of a friend from the desired position, or look for a guide picture on the internet. Even if the photo shows a real person instead of a manga character, you can still clearly recognize what you need to implement into the manga style.

Magical manga eyes

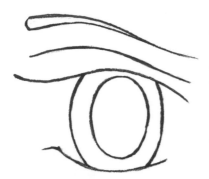

What is the first thing that comes to mind when you think of a manga character: the defining feature that tells you this is manga art? The large and very expressive eyes, of course. First and foremost, drawing manga means depicting emotions, and the more intense the emotions are the better. Nothing is a better vehicle for these emotions than the eyes, the windows to the soul. To render this emotion in two dimensions, manga artists will draw highlights of different sizes and shapes, a multifaceted iris, a good pupil and, last but not least, the eyebrows and eyelids.

 Once you have learned the basics, you can expand on the power of manga eyes and reinvent them in your own style.

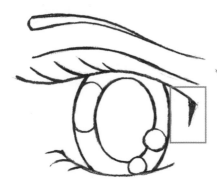

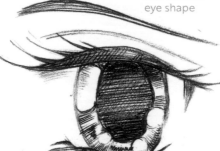

Harmonious eye shape

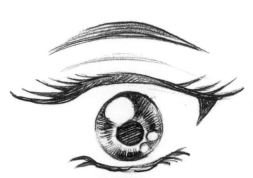

Astonished look

AN EYE IS FORMED

A few strokes are enough to establish the rough shape of a manga eye, after which you can draw in the highlights and eyelashes. The eyeball is not usually drawn with sharp lines, but is hinted at with short strokes or hooks, as you can see in the small blue box above.

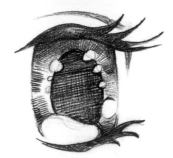

Tender look

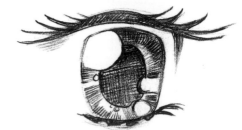

Neutral look

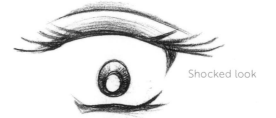

Shocked look

COMPARING GIRLS' AND BOYS' EYES

Although the design of an eye can vary greatly depending on the artist, there are a few standard differences when it comes to gender. Girls' eyes are usually very large and have many highlights drawn in. In contrast, boys' eyes – especially the iris and the pupils – are often smaller and depicted with fewer highlights.

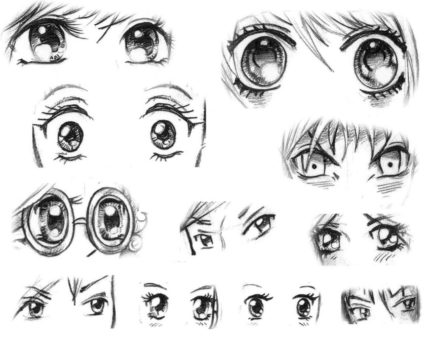

Girl's eye

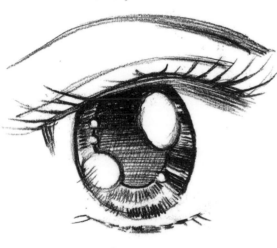

Boy's eye

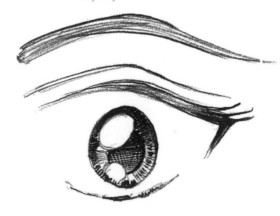

SMALL EYES, BIG EFFECT

In manga and anime (manga films), there are times when faces will fill the whole page or screen. You will also draw many small characters with tiny eyes. As the illustrations above show, the typical manga features need to be reduced to just a few elements to still achieve the desired expression (for example just one or two large highlights).

Details

IN REALITY

As with the anatomy of the head, it is worth making comparisons of how manga eyes differ from realistic drawings of eyes. Here you can see the same elements, – iris, pupil, eyebrow, eyelashes and eyelid – however, the proportions are markedly different with manga eyes.

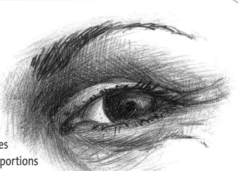

The iris and pupil are usually drawn large, and the highlights that intensify the expression are exaggerated and depicted more prominently than in a realistic drawing of an eye.

Secrets of the nose and mouth

The minimal design of the nose and mouth for most manga characters stands in stark contrast to the large eyes. The nose and mouth are often extremely small, sometimes consisting of just two dots.

There are, of course, good reasons for this. First, in a childlike style, a snub nose and a small mouth just look cuter. Also, it fits with the Japanese mentality to express more with the eyes than through words. If you sit on the Tokyo underground, for example, you will very often hear only silence.

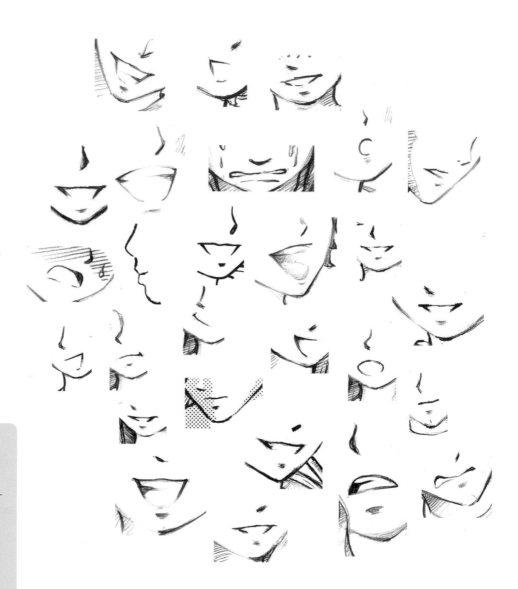

Good to know

Reducing the size of the nose and mouth gives the eyes even greater significance. The observer becomes captivated by them, without being distracted by other illustrated features. The art is in combining the small dots and arcs as secret signs that are in harmony with the eyes.

SIMPLE STROKES

Here you can see a collection of noses and mouths. Although they are drawn with only a few strokes, the emotions are well expressed. Short strokes are enough to hint at teeth and tongues. For open mouths – like the example in the top-left – the interruption of the lower lip is enough to create an impression of gleaming white teeth.

Details

IN REALITY

If you study your own nose and mouth, you will see that they are not defined by sharp lines or edges. Almost everything (apart from the mouth opening) is modelled out of the face using light and shade (represented through hatching in a drawing). This is also the reason manga faces are drawn with very few outlines.

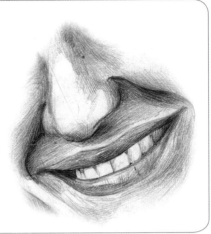

DECEPTIVE SIMPLICITY

At first glance, drawing the nose and the mouth looks very easy: a few dots and lines and it's done. However, like so many things, it is the very simplicity that makes it so difficult. How do you draw a mouth beaming with joy or a lip trembling with anger out of almost nothing?

It is important to keep practising this drawing process and, above all else, to see how other artists manage to convey expression. As you can see with the mouths above, there is a whole range of expressions you can use to portray your character's mood.

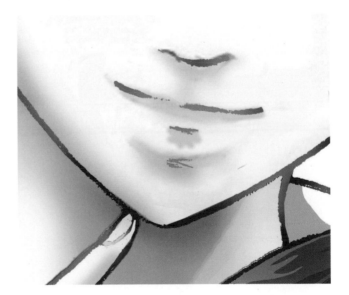

ACHIEVING SUBTLE SHADOWS

Simplicity is a principle that applies to colouring the lower part of the face as well as to drawing it. A few subtle shadows are enough to sculpt the nose and mouth out of the face. To achieve this – whether digitally or by hand – choose a darker version of the skin colour on the rest of the face and apply that underneath the nose, lips and at the base of the chin.

Girls' hairstyles

After the eyes, the hair is probably the next-most important stylistic element of a manga character. It is through the hair that you define the style that determines the nature of your character.

Manga hair is given a great deal of life – it is often very voluminous and frames the face to emphasize the depiction of emotions. Shojos usually have a ponytail and accessories such as flowers or hairbands. However, there are, of course, lots of hairstyles, and as a manga artist you are also a hairstylist! Consider what your character represents, in what time she is living and what sort of traits she has. You can then style the hair to complement the character.

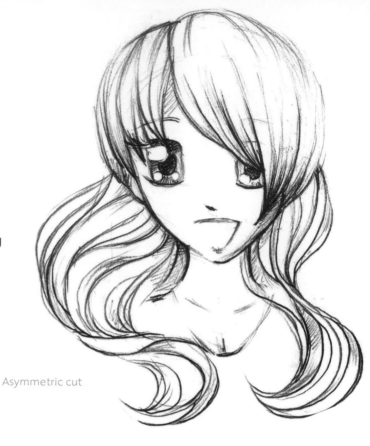

Asymmetric cut

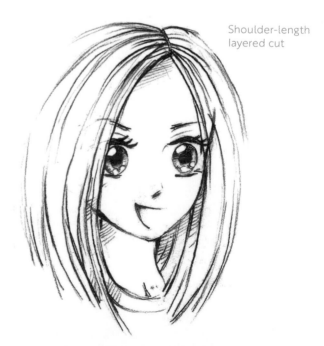

Shoulder-length layered cut

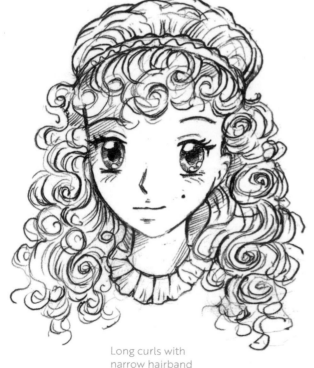

Long curls with narrow hairband

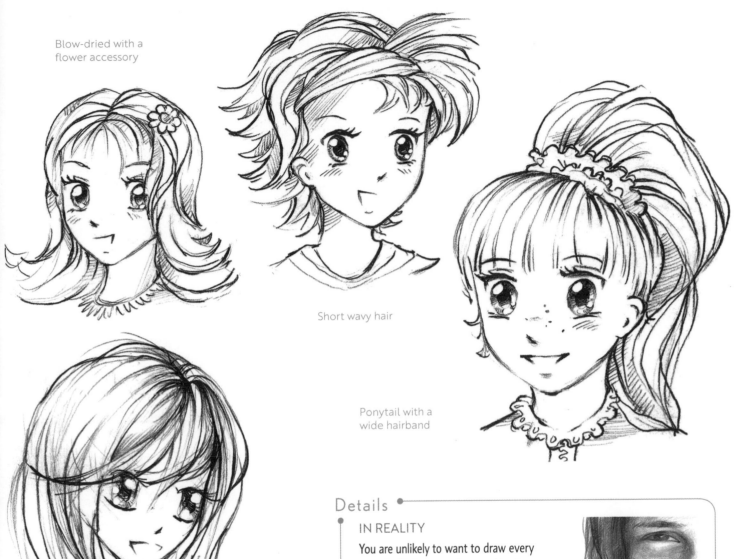

Blow-dried with a flower accessory

Short wavy hair

Ponytail with a wide hairband

Loose long hair

Details

IN REALITY

You are unlikely to want to draw every strand of hair, even when working in a realistic style like this. Be brave and leave gaps, and know that areas of white give hair a shiny effect.

Instead of drawing individual strands of hair, select a number of strands and put them together artistically to achieve the typical manga look.

Boys' hairstyles

It is possibly more difficult to give a manga boy an original hairstyle than it is a manga girl. Manga boys are generally drawn with short or mid-length hair with tapered strands that stand up proud from the head and convey a 'cool' appearance – a very typical hairstyle for shonen and any kind of fighter character. Alternatively, you can choose the softer styles associated with bishies, which give a more feminine look.

Even if the design possibilities do not compare with those for girls, you should still aim to give your character a unique hairstyle that helps communicate his personality.

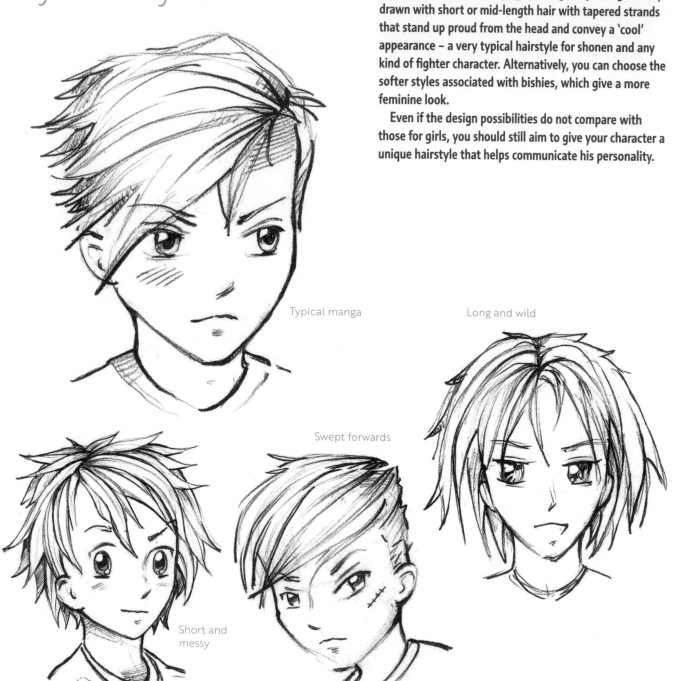

Typical manga

Long and wild

Swept forwards

Short and messy

Good to know

Shojo (female) characters are the most well-known of the manga styles, with their shining eyes and flowing hair. However, boys also play an important role in the stories, as well as in the ever-more popular shonen stories.

Bishies, the male version of shojos, need not always look the same in terms of hair design. So use your creativity to try out new things and design hairstyles that no one has seen before!

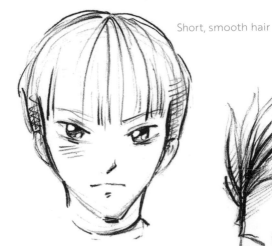

Short, smooth hair

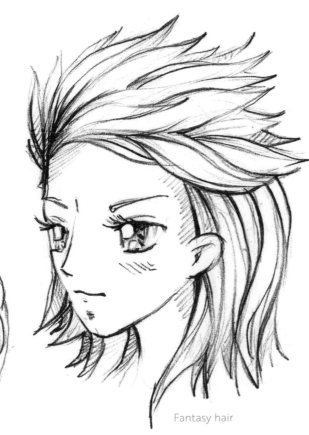

Fantasy hair

Shoulder-length style

Spikes

Details

IN REALITY

In real life, the main difference between girls' and boys' hair is often the length: boys are commonly drawn with short or shoulder-length hair, as shown here.

In manga designs, boys' short hairstyles are usually given a spiky look.

Suggesting hair colour

Making pencil sketches is the first stage of developing your manga characters. The typical manga look, however, is very different, with the drawings outlined and shaded using fineliners, ink brushes or markers. Areas that are not filled in – but left as white paper – create highlights and other effects. Sharp outlines, areas of solid black and areas of grey shading create the look we are all familiar with.

You can either use a fineliner to draw directly over the pencil sketch before rubbing the pencil lines away, or, if you don't want to lose the sketch, use a light box to trace over the lines onto a separate piece of paper.

Details

MAKE YOUR OWN HAIR LIBRARY

In Japan, some mangas are produced quickly – this is only possible when the artists keep a database featuring elements of their characters that they can refer to, reuse and add to whenever they need it. Anyone can create an image library for themselves, whether by hand-drawing or using computer graphics. These two hairstyles are a good example of how something like this can look.

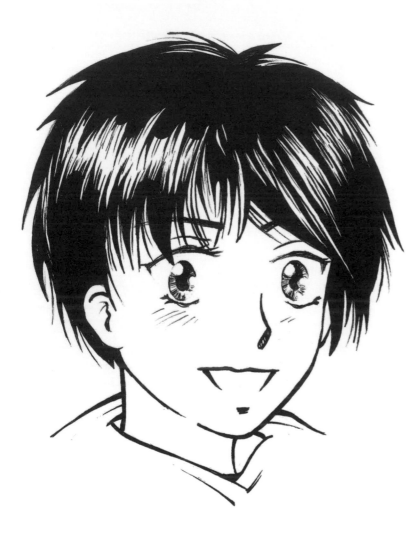

SOLID COLOUR AND FINE SHINE

This boy's hairstyle is helpful in studying this drawing technique. The large area of solid black depicts much of the hair, interrupted in a specific area with white highlights. This creates the impression of shining hair, and the white lines stand out from the black.

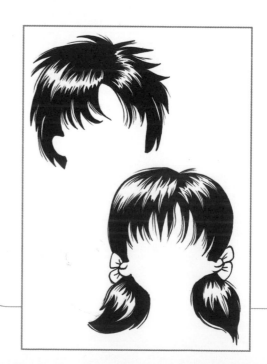

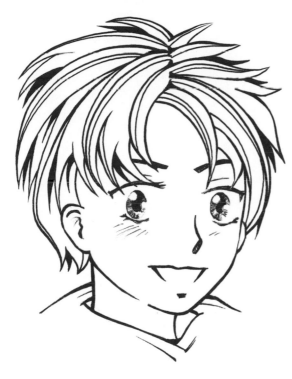

OUTLINE ONLY

In this variation, only the outline is drawn with the fineliner. Except for a few strands of hair at the back, the spaces inside the outline are left white. This gives the impression of blond hair, even though no colour is used.

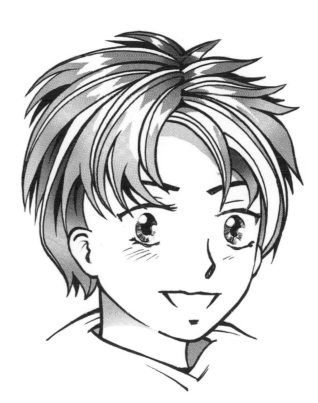

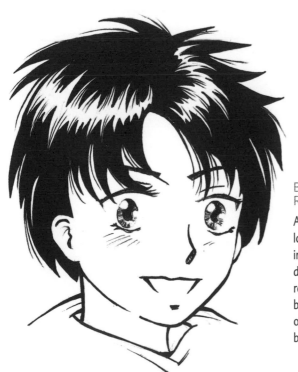

BLACK SURFACE AREA, REDUCED DESIGN

At first glance, this representation looks almost the same as the large image, opposite. However, the detail of the strands is significantly reduced, as the smaller a drawing becomes, the more you have to focus on the essential details such as the black surface area of the hair.

SCREENTONE

Here the line drawing is supplemented with screentone in various gradations of grey. The hair appears slightly darker than the previous example, but not as dark as the solid black colouring. This is a very common technique that can be done by hand or digitally, and it leaves a lot of room for creativity. We will go into more detail about screentone later in the book.

Young heroes – strong emotions

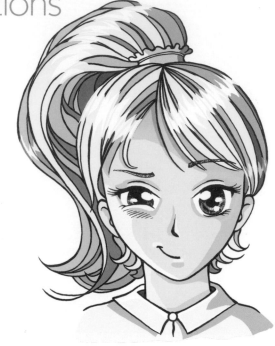

You have already learned a lot about the basic structure of a head, and about the importance in Japanese manga culture of depicting intense emotions. But how do you portray these emotions? How can you make a face look angry or happy? Here is a simple guide to get you started on expressing emotion through facial expression. The most important thing is to observe how faces change in certain situations, and to consider how to capture these moods with just a few lines on paper.

On pages 60–67 we will go one step further, looking at how emotions are not only expressed through the face, but also through the entire body.

Details

A SIMPLE STARTING FORMULA

As emotions change, they are naturally reflected in a person's facial expression. It is the facial muscles that cause these changes. The angrier someone is, the more their facial features will tense up towards the centre (bottom-left). The happier someone is, the more their face will open up in arcs around this facial centre (bottom-right).

Capturing the lines of the face becomes more complicated when emotions are more complex, as shown on the opposite page.

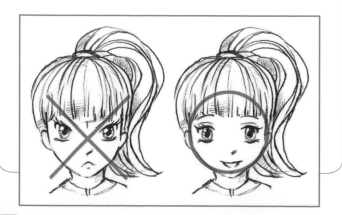

USE A TEMPLATE TO PRACTISE

A good way to experiment with drawing different facial expressions is to use a template of a face without the eyes, nose or mouth. This can be copied as many times as you like to try out new facial expressions. Don't forget that with manga art the emotions should be exaggerated as much as possible!

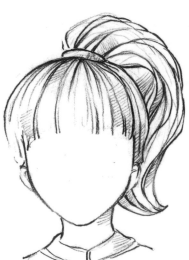

Practice template

Angry or defiant

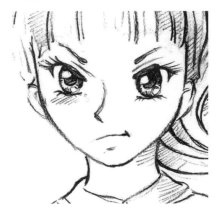

Relaxed or calm

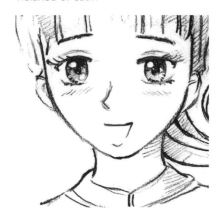

Dreamy

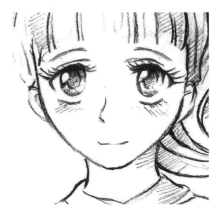

Dismayed or melancholic

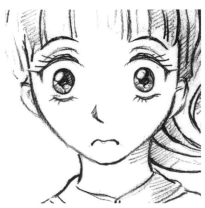

Sad or desperate

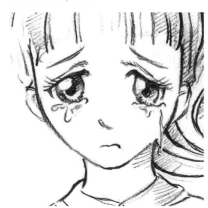

Puzzled or exhausted

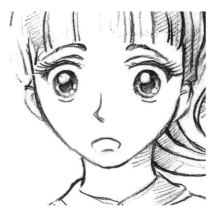

Clever or witty

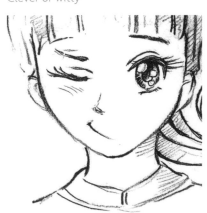

Startled or panicked

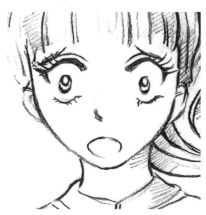

Embarrassed

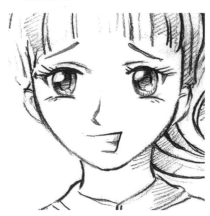

Hands and feet

BASIC STRUCTURE

Hands have a basic structure that you can study to make drawing them easier. To understand the anatomy of the hand you can either draw it in small segments, as shown below, left, or draw the joints and the palm as circles, which you can use as your guides when changing the position of the hand (below-centre).

When drawing manga it is as important to achieve a good representation of hands and feet as it is with the rest of your character, but it is a task often disliked by artists due to its level of difficulty. It takes some effort to master the skills of drawing hands and feet accurately. However, it is worth the effort!

When creating a character, hands can convey as much expression as the body or face. Imagine each hand as a small, self-contained universe with its own unique stylistic possibilities.

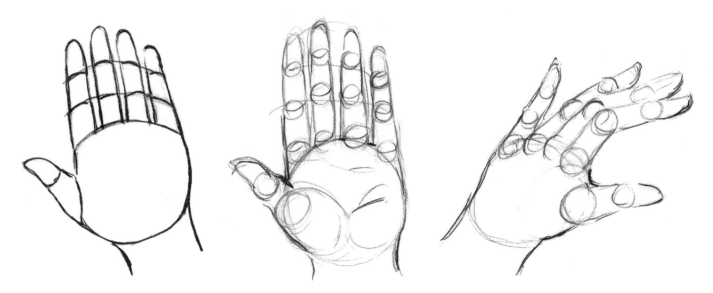

Details

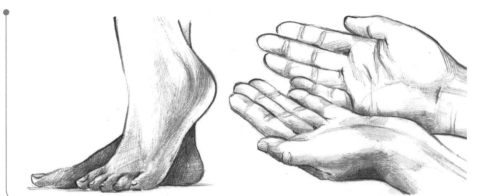

IN REALITY

Experienced artists often use their own or a friend's hands and feet as a reference when a certain pose is proving problematic to draw.

Alternatively, you can find photographs on the internet and use them as a reference if you get stuck.

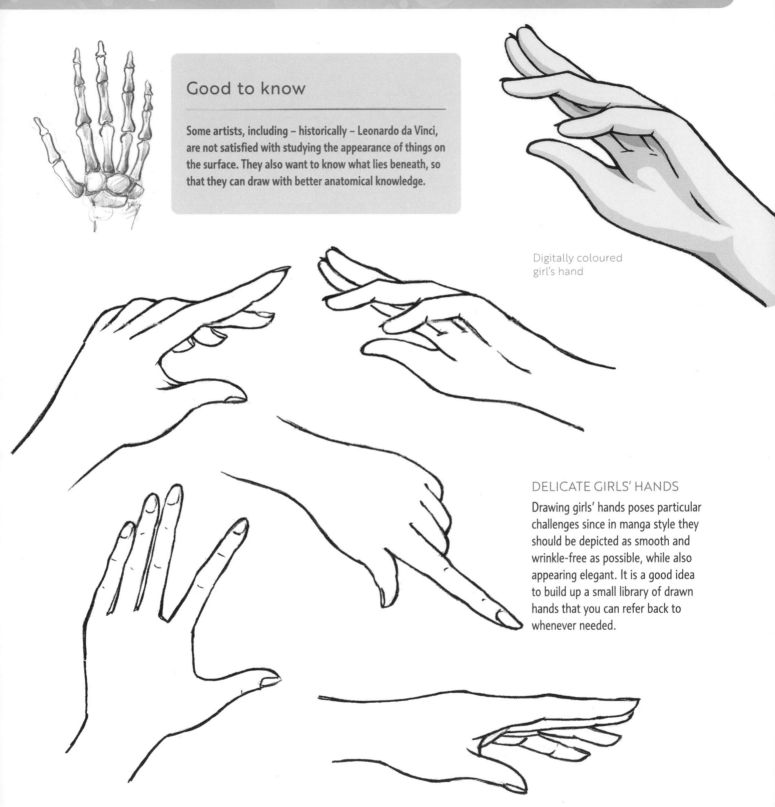

Good to know

Some artists, including – historically – Leonardo da Vinci, are not satisfied with studying the appearance of things on the surface. They also want to know what lies beneath, so that they can draw with better anatomical knowledge.

Digitally coloured girl's hand

DELICATE GIRLS' HANDS

Drawing girls' hands poses particular challenges since in manga style they should be depicted as smooth and wrinkle-free as possible, while also appearing elegant. It is a good idea to build up a small library of drawn hands that you can refer back to whenever needed.

With some drawing practice, you can start to differentiate between girls' hands and boys' hands. Boys' fingers, for example, are slightly more robust, and may feature small wrinkles at the joints. Their poses are less elegant and more dynamic and, in the case of shonen, usually forceful or aggressive.

BOYS' HANDS

In these expressive poses you can clearly see the differences between male and female hands. Drawing hands is a skill that needs to be practised repeatedly in order to continue to improve.

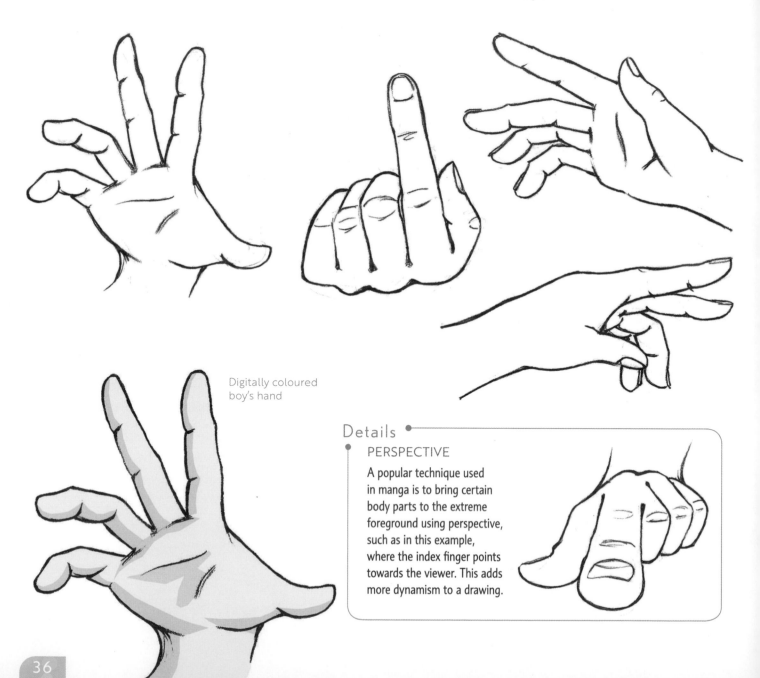

Digitally coloured boy's hand

Details

PERSPECTIVE

A popular technique used in manga is to bring certain body parts to the extreme foreground using perspective, such as in this example, where the index finger points towards the viewer. This adds more dynamism to a drawing.

VARIATIONS IN HAND DESIGNS

Here are some examples of different hand designs that would be appropriate for particular characters.

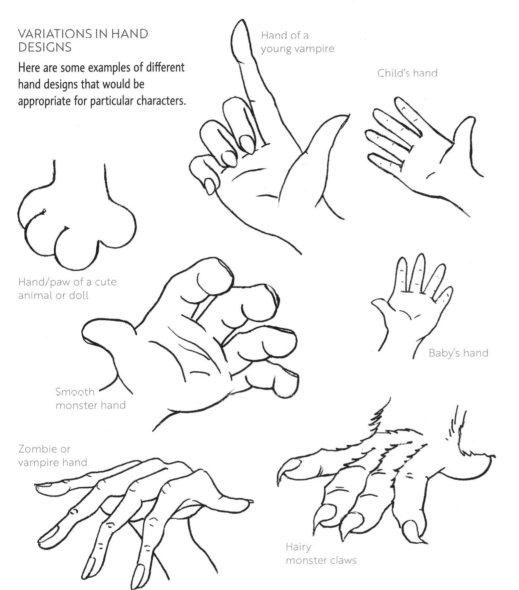

Hand of a young vampire

Child's hand

Digitally coloured child's hand

Hand/paw of a cute animal or doll

Smooth monster hand

Baby's hand

Zombie or vampire hand

Hairy monster claws

Good to know

A character design consists of several components that must correlate with each other. This is a concept that should always be considered during character design. For example, the hands and feet should suit the body, and the body in turn should suit the face, otherwise your character won't look right and will confuse the viewer.

SPECIAL COLOURS

A zombie or a vampire won't have a natural skin tone, so the colour scheme you choose should be adjusted to suit your character.

Shojos, bishies, chibis and shonens are well-known manga characters, but there are others. You'll find a few examples throughout the book. If you want to draw a vampire, a zombie or a monster, you will need to design the hands to suit the character. The same goes for babies, cute animals, dolls or toys.

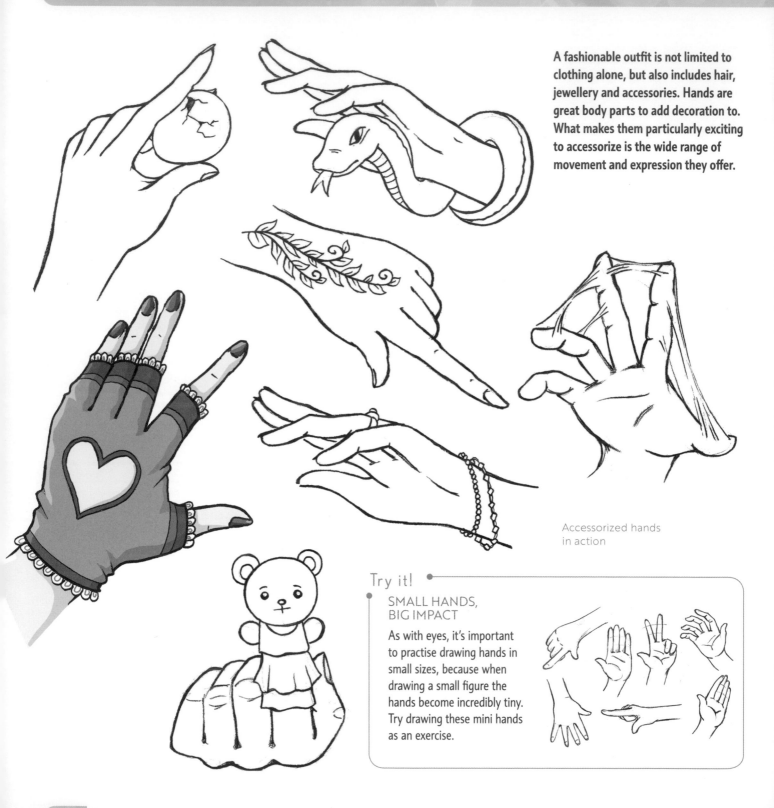

A fashionable outfit is not limited to clothing alone, but also includes hair, jewellery and accessories. Hands are great body parts to add decoration to. What makes them particularly exciting to accessorize is the wide range of movement and expression they offer.

Accessorized hands in action

Try it!

SMALL HANDS, BIG IMPACT

As with eyes, it's important to practise drawing hands in small sizes, because when drawing a small figure the hands become incredibly tiny. Try drawing these mini hands as an exercise.

Drawing feet is not the most popular task for artists. It's probably because we see feet less frequently than hands, making their forms more challenging to grasp. Additionally, feet are usually covered by shoes.

You will find lots of examples of shoes throughout the book, but to begin with it is a good idea to study the bare foot, since understanding the anatomy of a foot will make it easier to tackle shoes later on.

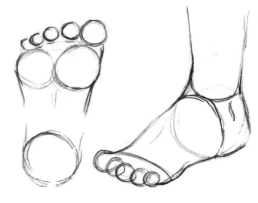

Various feet

BASIC STRUCTURE

Using circles to mark out the structure of the foot and its joints, similar to the technique discussed for hands, makes this part of the body much easier to draw. The position of the big toe, which is located on the inner side of the foot, is important.

Good to know

The structure of the foot is very complex. Small bones, muscles and ligaments all ensure that the foot can support the whole body weight. The feet of manga girls are often delicate and yet full of strength.

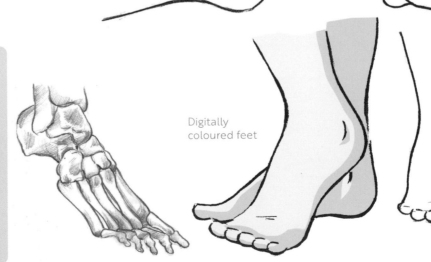

Digitally coloured feet

Anatomy of a manga character

In the first part of this chapter, we extensively covered the topic of drawing the head and face, as well as hands and feet. Now we will delve into the equally fascinating process of drawing the body. As with faces, a wide range of possibilities exists for designing the figure, depending on the preferred manga style. However, the drawing approach remains consistent regardless of the style, and once understood, it enables you to create and animate almost any type of character.

Vertical central axis

Guidelines for eyes

The upper arm and forearm are almost the same length

Details •

COMPARISON OF STYLES

Knowing the proportions of the human body in its basic form makes it easier to go on to draw a manga body. To draw in the manga style means translating anatomical reality into a new artistic representation.

You can see this concept in this example of three teen girls. In the centre is a realistic representation.
On the left is a shojo style and on the right a chibi style. Both of the manga versions are characterized by their large eyes. In the case of the chibi girl, the head is drawn disproportionately large. Compared to the realistic example, the shojo teen's legs are elongated, her head is slightly smaller and her hair more voluminous.

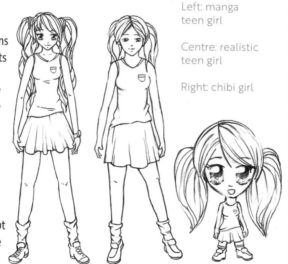

Left: manga teen girl

Centre: realistic teen girl

Right: chibi girl

The fingertips end at the middle of the thigh

Circles for joints

The thigh and lower leg are almost the same length

Long legs in relation to the upper body

THE BODY STRUCTURE OF A TEEN GIRL IN MANGA STYLE

Use this large-scale depiction of the anatomical structure of a manga character to help you draw and develop your figures.

If you struggle to draw the body structure to start with, you can simply trace the template opposite. However, it's still important to practise drawing the figure to get more comfortable and proficient with the process, which will allow you to more easily create your own manga characters! Drawing the joints as circles is extremely helpful in this process.

On this page, you can see how a manga girl and a manga boy were developed from the same template (except for the chest area).

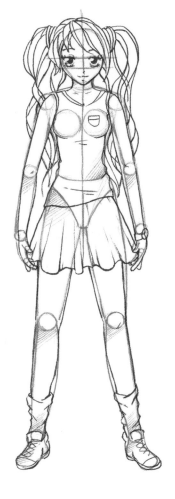

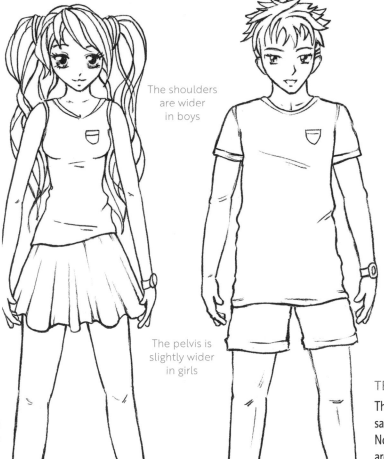

The shoulders are wider in boys

The pelvis is slightly wider in girls

TEENAGE GIRL

Draw the basic structure of the figure (shown in light blue above) lightly, so that you can trace over it with a softer pencil, or, later, with a fineliner.

TEENAGE BOY

The boy is drawn based on the same basic structure as the girl. Notice that his shoes and hands are larger, and his arms are more muscular.

Manga movement

Now things get really exciting, because your characters are about to come to life! Drawing bodies means depicting movement combined with emotions. A manga story won't captivate the reader if the drawn characters are static and always facing front. Therefore, it is important to learn how to depict a body in motion and in different poses – and even more important to learn how to exaggerate and overemphasize the poses to make them as emotional as possible.

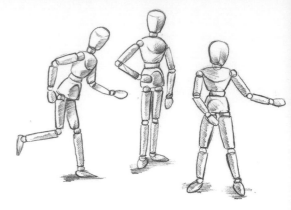

Wooden lay figures (mannequins) are available from art shops and can recreate almost any pose. They are excellent tools for studying challenging figure positions

Vertical central axis

An arm, a leg, a hip and a shoulder disappear behind the body and then reappear

Back curvature

Don't forget the calf muscles!

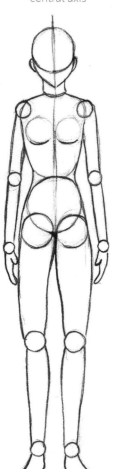
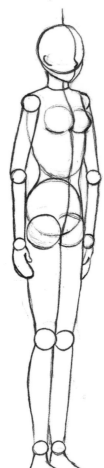
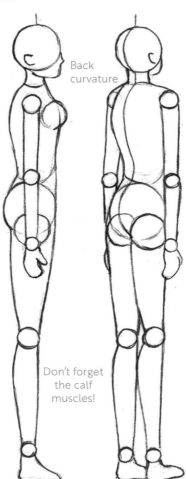
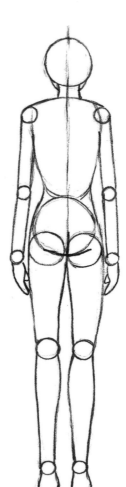

TURNAROUND

A turnaround refers to the sequence of views of a body in a complete rotation around its own axis. If you don't have a lay figure, you can refer to photos or use these illustrations as a reference for drawing the figure from various viewpoints.

Details

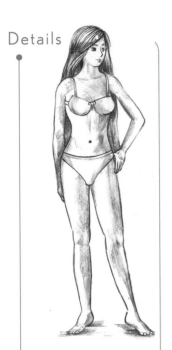

IN REALITY

In a realistic drawing, the head makes up approximately one-seventh of the total body height. However, when drawing manga characters, this size ratio often shifts significantly, depending on the chosen style.

SIMPLE MOVEMENTS

These illustrations depict various simple movements: the top row shows figures in their basic form, while the bottom row shows the direct portrayal in a manga style.

The vertical axis, chest and shoulder height, as well as the hip, shift depending on the movement sequence

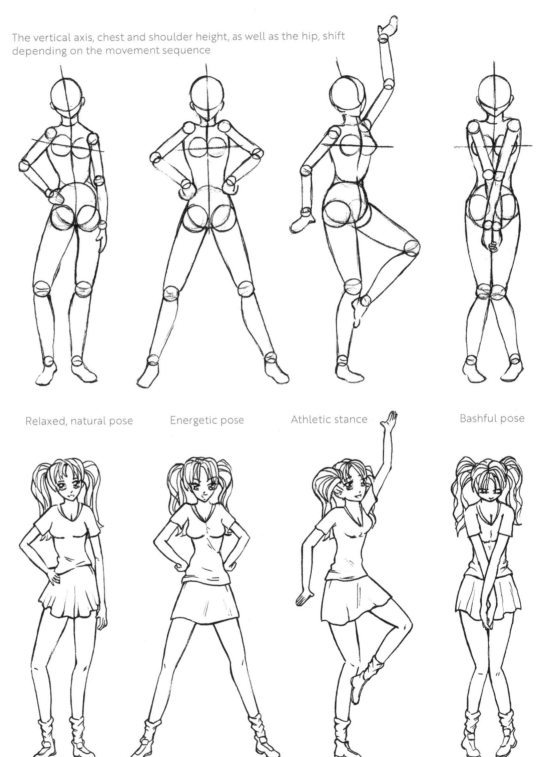

Relaxed, natural pose Energetic pose Athletic stance Bashful pose

The same principles of turning realistic figures into manga art apply for all sorts of manga characters, as you can see with the examples here. The main changes are in the sizes of individual body parts and their proportions to one another. The artistic process based on simple basic shapes and joints represented as circles remains the same.

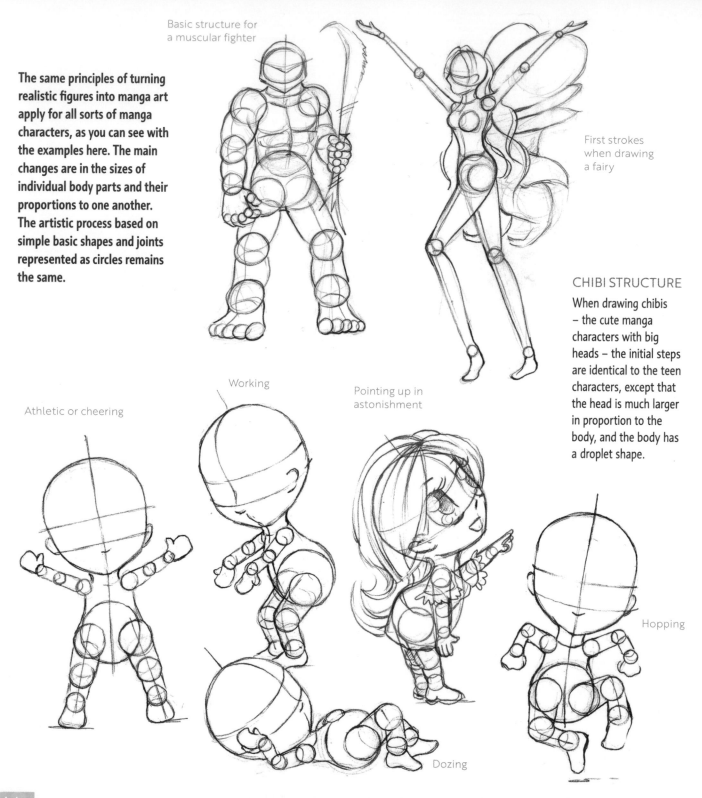

Basic structure for a muscular fighter

First strokes when drawing a fairy

CHIBI STRUCTURE

When drawing chibis – the cute manga characters with big heads – the initial steps are identical to the teen characters, except that the head is much larger in proportion to the body, and the body has a droplet shape.

Athletic or cheering

Working

Pointing up in astonishment

Dozing

Hopping

Perspective and the manga figure

If you want to become a really good manga artist, take a close look at the following pages, which cover perspectives of the figure that, although difficult to render, can give your drawings a real kick when applied correctly. Only a few artists can master these depictions.

DEVELOPMENT

Every detail needs to adhere to the rules of perspective. Often the changes in proportions are misjudged.

STILL CIRCLES

The basic structure when drawing characters from an interesting perspective viewpoint still revolves around simple shapes and circles for joints.

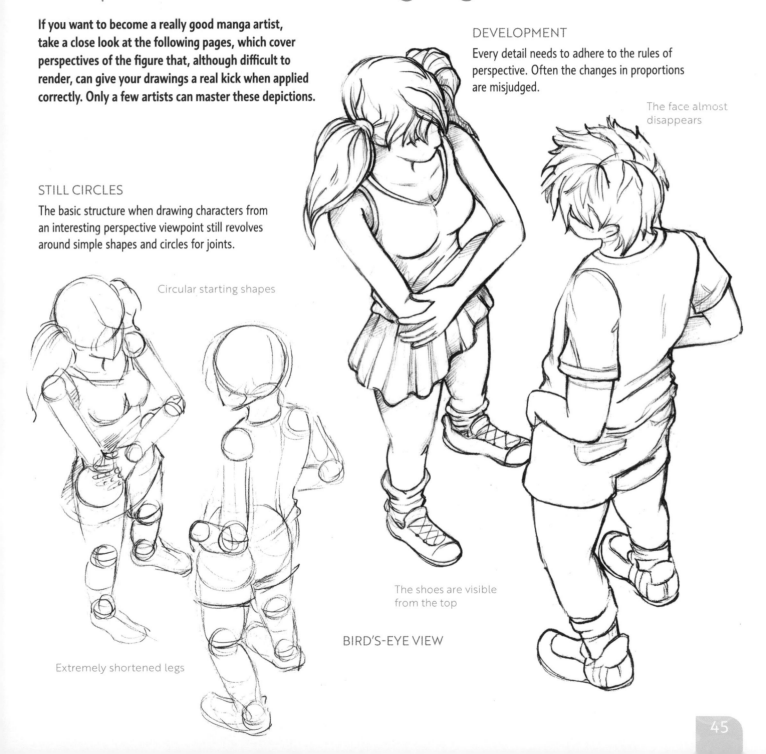

The face almost disappears

Circular starting shapes

The shoes are visible from the top

BIRD'S-EYE VIEW

Extremely shortened legs

WORM'S-EYE VIEW

The worm's-eye viewpoint is a challenging choice. You are more likely to see people from above (such as on escalators) than you are from below, so the worm's-eye angle is not something you are likely to be very familiar with.

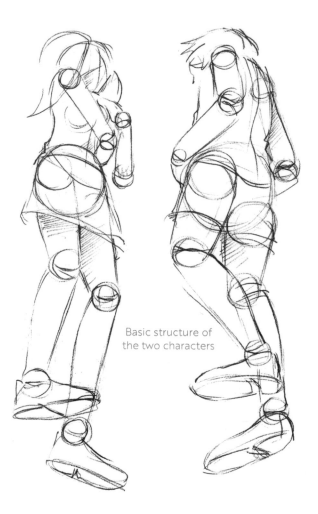

Basic structure of the two characters

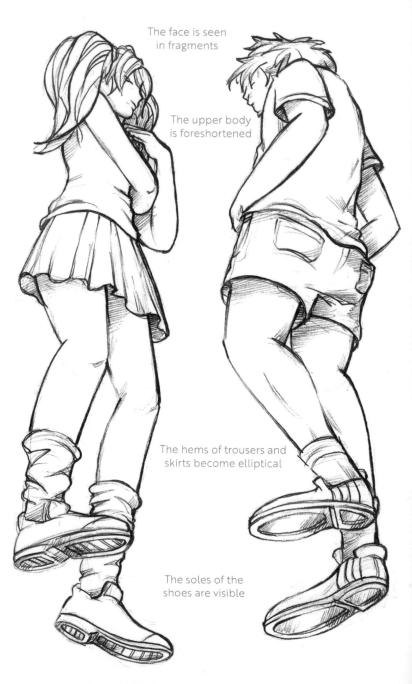

The face is seen in fragments

The upper body is foreshortened

The hems of trousers and skirts become elliptical

The soles of the shoes are visible

Good to know

It is nearly impossible to draw challenging perspectives from memory without extensive practice. Therefore, it is best to refer to freely available photos from the internet or, even better, create your own photo archive from specific perspective viewpoints.

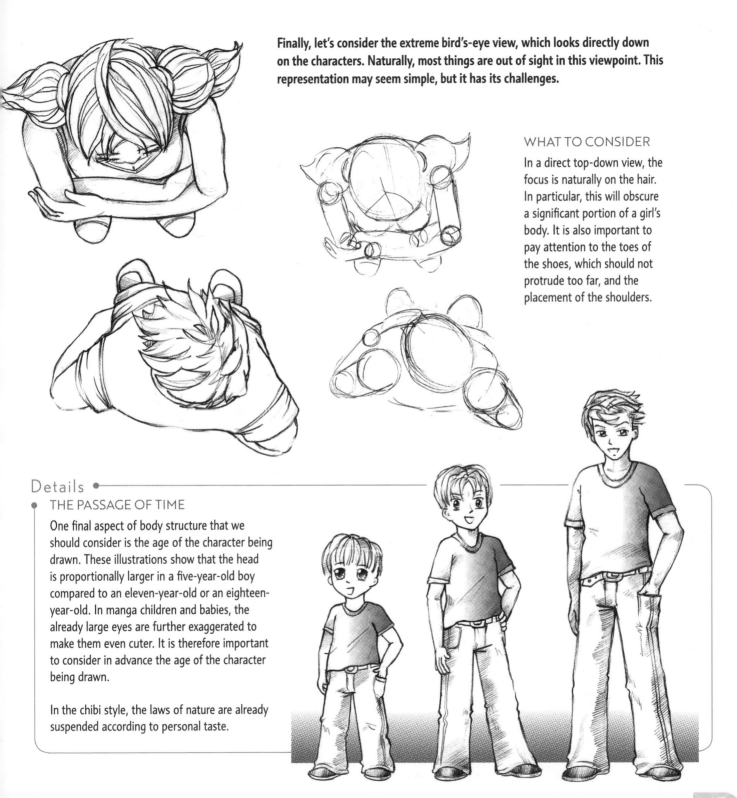

Finally, let's consider the extreme bird's-eye view, which looks directly down on the characters. Naturally, most things are out of sight in this viewpoint. This representation may seem simple, but it has its challenges.

WHAT TO CONSIDER

In a direct top-down view, the focus is naturally on the hair. In particular, this will obscure a significant portion of a girl's body. It is also important to pay attention to the toes of the shoes, which should not protrude too far, and the placement of the shoulders.

Details

THE PASSAGE OF TIME

One final aspect of body structure that we should consider is the age of the character being drawn. These illustrations show that the head is proportionally larger in a five-year-old boy compared to an eleven-year-old or an eighteen-year-old. In manga children and babies, the already large eyes are further exaggerated to make them even cuter. It is therefore important to consider in advance the age of the character being drawn.

In the chibi style, the laws of nature are already suspended according to personal taste.

Fashion and emotions

There are two things that significantly shape manga stories: intense emotions expressed through the main protagonists, and the outfits of the girls and boys depicted. The feelings of the characters are expressed through eyes, gestures and even hair. The respective fashion styles define the character of the boy or girl portrayed and, above all, the time period and environment in which the character exists.

This chapter is about fashion trends, cool outfits and intense emotions.

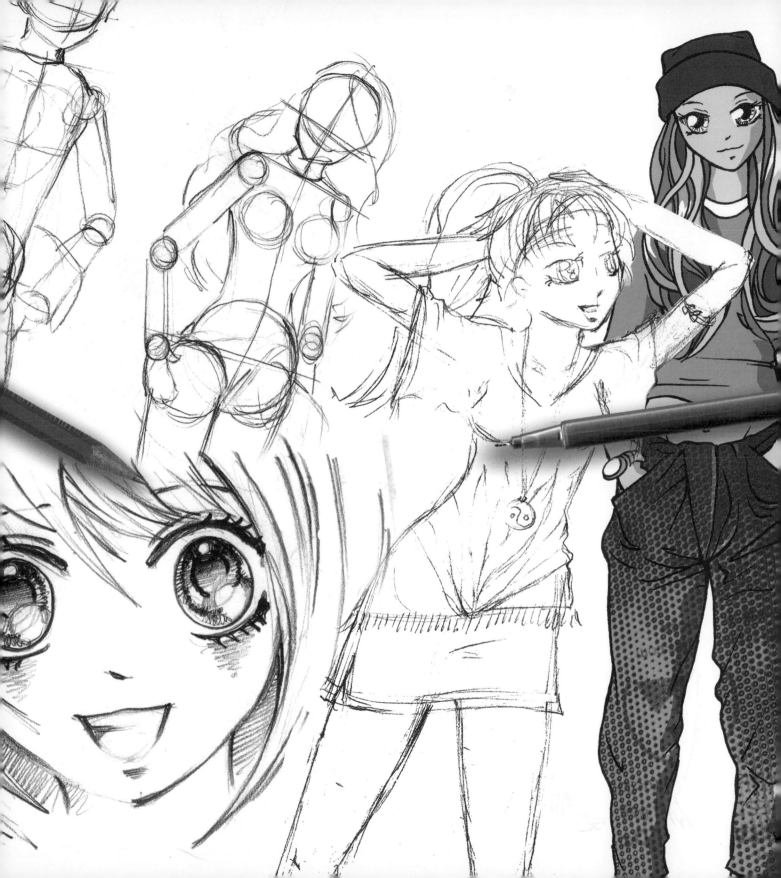

The school uniform

School uniforms are mandatory in Japan, and lots of manga stories take place in high schools, so it's not surprising that many manga heroes wear school uniforms. However, if you think school uniforms are boring, think again! Individuality is in the details and how the uniforms are worn. A seemingly dull school uniform can quickly transform into a fun outfit.

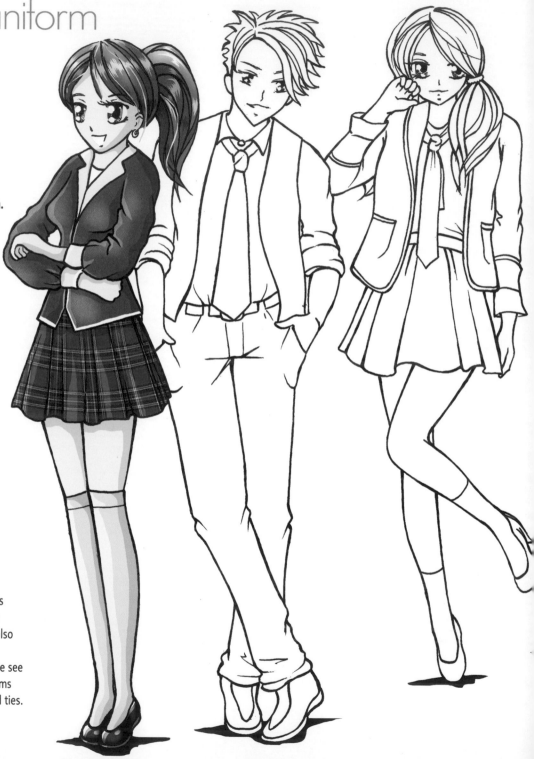

TYPES OF SCHOOL UNIFORM

Among the different styles of school uniform, you will find that some lean towards a sporty style, while others exude elegance. Students also have appropriate attire for different occasions. Here we see three elegant school uniforms featuring jackets, shirts and ties.

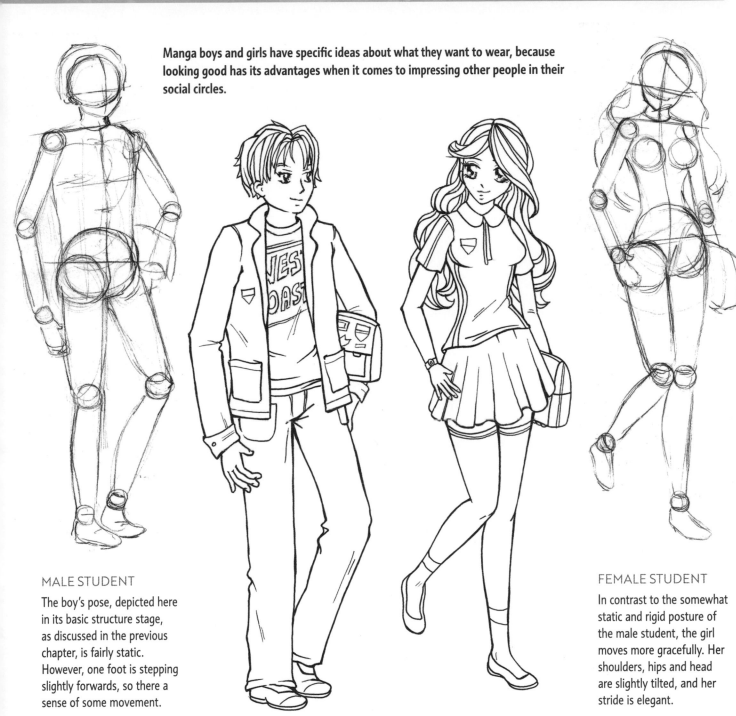

Manga boys and girls have specific ideas about what they want to wear, because looking good has its advantages when it comes to impressing other people in their social circles.

MALE STUDENT

The boy's pose, depicted here in its basic structure stage, as discussed in the previous chapter, is fairly static. However, one foot is stepping slightly forwards, so there a sense of some movement.

SPORTY OUTFIT

School uniforms can have a sporty twist! The boy wears a printed shirt under the jacket, and the girl wears a fitted sports top.

FEMALE STUDENT

In contrast to the somewhat static and rigid posture of the male student, the girl moves more gracefully. Her shoulders, hips and head are slightly tilted, and her stride is elegant.

What's your style?

On the catwalks of the world, from Paris to New York, the latest fashion trends are presented every year. In Japan in particular, where culture is rooted in ancient traditions, there is a strong inclination towards innovation and an interest in styles from the Western world. These trends are reflected in manga art and, equally, manga artists inspire fashion designers.

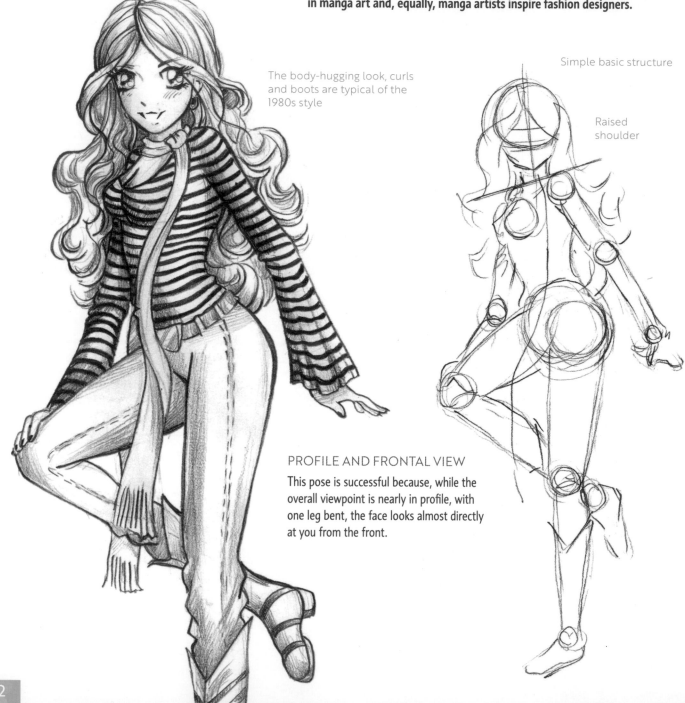

The body-hugging look, curls and boots are typical of the 1980s style

Simple basic structure

Raised shoulder

PROFILE AND FRONTAL VIEW

This pose is successful because, while the overall viewpoint is nearly in profile, with one leg bent, the face looks almost directly at you from the front.

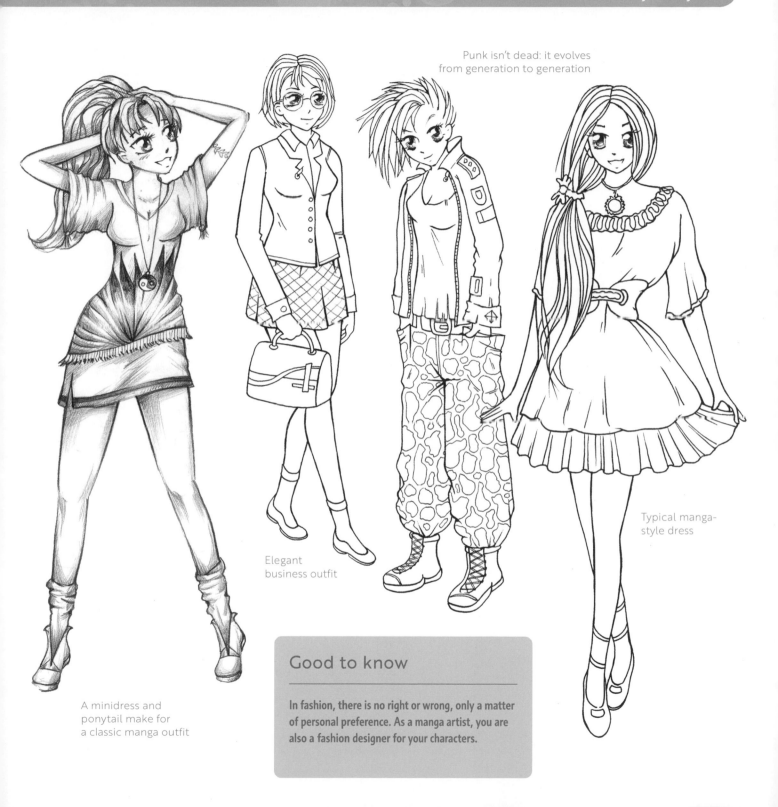

Punk isn't dead: it evolves from generation to generation

Elegant business outfit

Typical manga-style dress

A minidress and ponytail make for a classic manga outfit

Good to know

In fashion, there is no right or wrong, only a matter of personal preference. As a manga artist, you are also a fashion designer for your characters.

Fashion trends

Hip-hop style

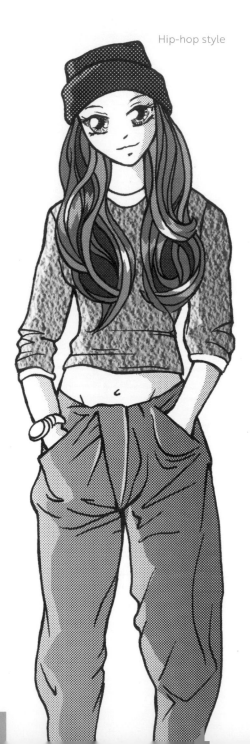

Fashion doesn't just change over the years; there are also simultaneous fashion trends that appeal to the same generation, even though they may be very different. You can see some examples of this here.

Each youth culture chooses its own fashion style, which is then reflected in the drawings of manga artists.

Details

COLOUR MAKES ALL THE DIFFERENCE

The design of the clothes is one aspect of fashioning your manga character, but you also need to consider your choice of fabrics and colours. Wearing the same design of outfit, you can see how the look changes when clothing colours and skin tone are adjusted.

If you choose to colour your characters at a later stage of the drawing process, it is still a good idea to consider the impact of colour as you design.

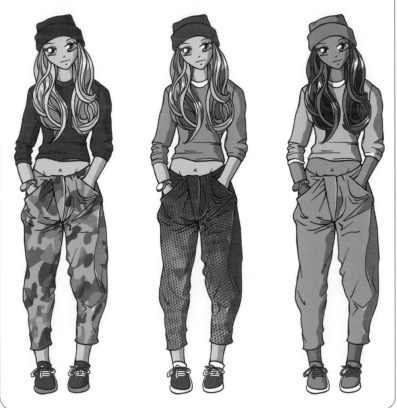

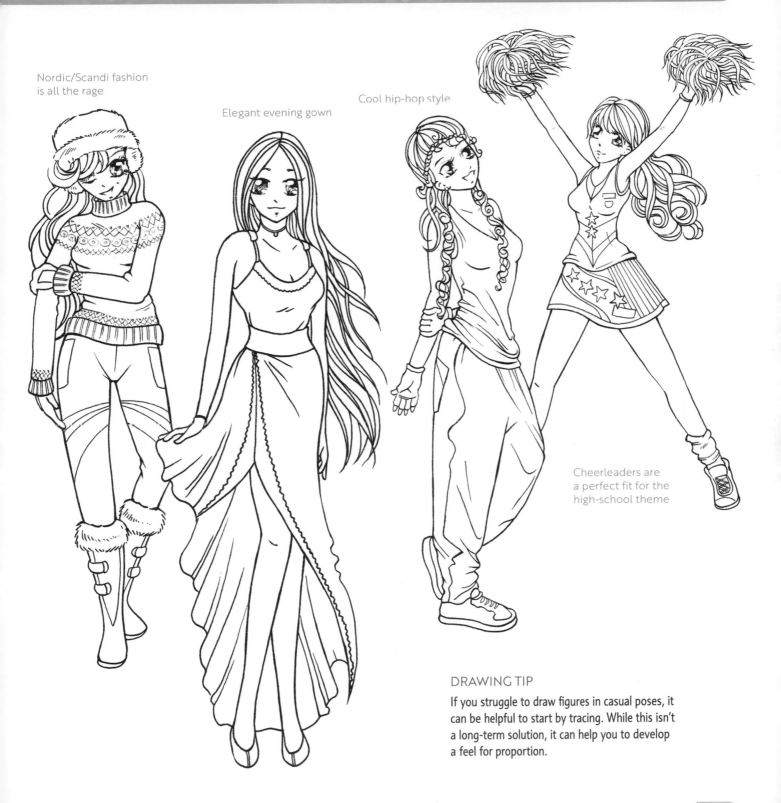

Nordic/Scandi fashion
is all the rage

Elegant evening gown

Cool hip-hop style

Cheerleaders are
a perfect fit for the
high-school theme

DRAWING TIP

If you struggle to draw figures in casual poses, it
can be helpful to start by tracing. While this isn't
a long-term solution, it can help you to develop
a feel for proportion.

Boys' fashion

It is a cliché to suggest that boys are fashion-shy. They care about their appearance and carefully consider which shirt, trousers and cap match their style. As a manga artist this is what you need to do for your male characters too. Here are a few examples.

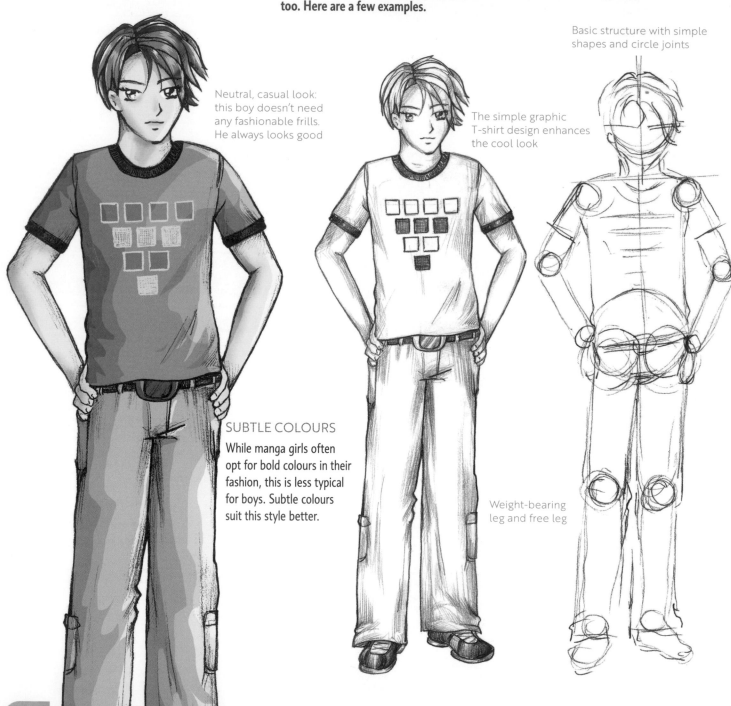

Neutral, casual look: this boy doesn't need any fashionable frills. He always looks good

Basic structure with simple shapes and circle joints

The simple graphic T-shirt design enhances the cool look

SUBTLE COLOURS

While manga girls often opt for bold colours in their fashion, this is less typical for boys. Subtle colours suit this style better.

Weight-bearing leg and free leg

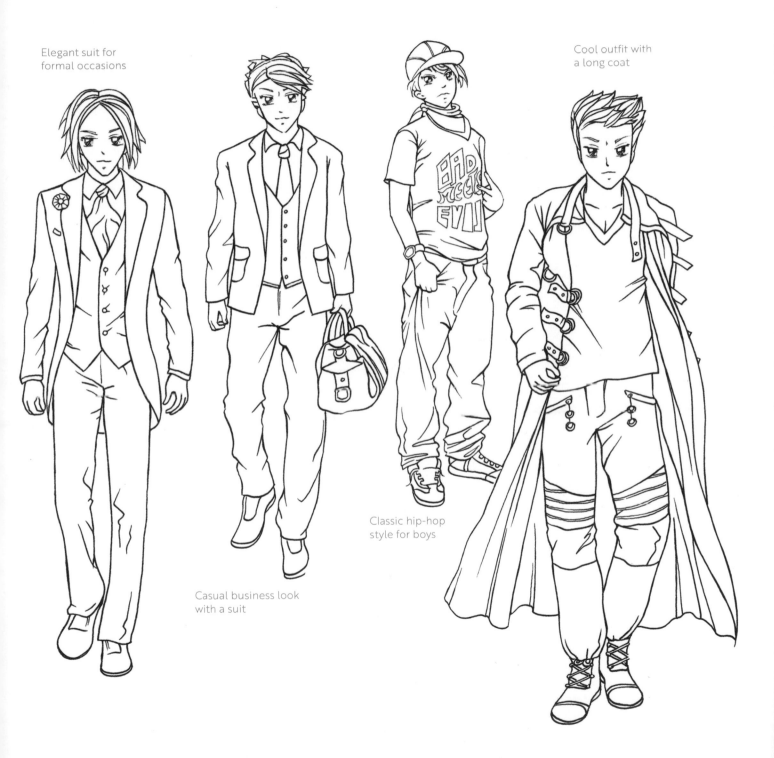

Elegant suit for
formal occasions

Cool outfit with
a long coat

Classic hip-hop
style for boys

Casual business look
with a suit

Magical transformation

The classic manga theme for girls is shojo (or shoujo in the original spelling). It often revolves around the feelings and adventures of schoolgirls. Authors also delve into other manga genres, such as fantasy or science fiction, and the female characters can acquire supernatural abilities and live in parallel worlds. They become what is known as magical girls, providing the artist with a wealth of creative possibilities. Shy schoolgirls turn into heroes with superpowers.

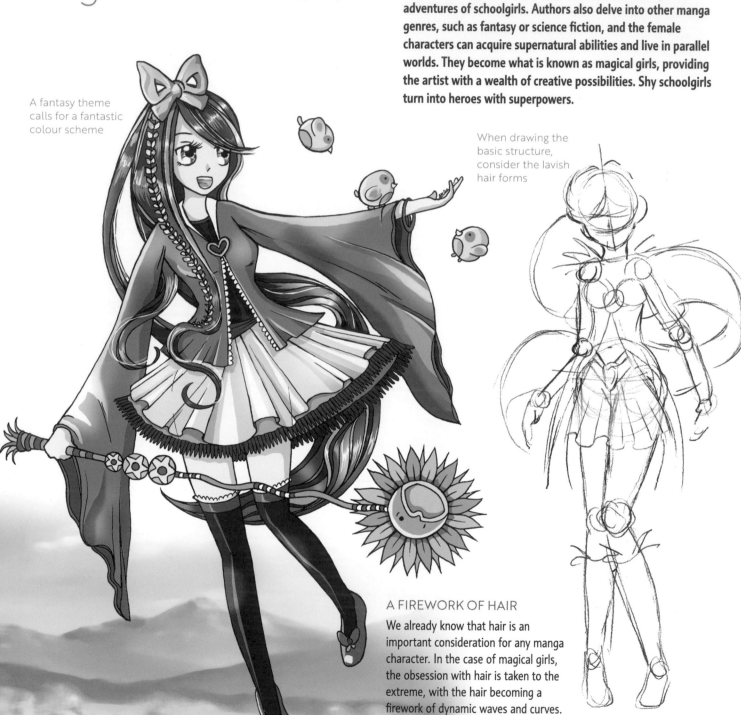

A fantasy theme calls for a fantastic colour scheme

When drawing the basic structure, consider the lavish hair forms

A FIREWORK OF HAIR

We already know that hair is an important consideration for any manga character. In the case of magical girls, the obsession with hair is taken to the extreme, with the hair becoming a firework of dynamic waves and curves.

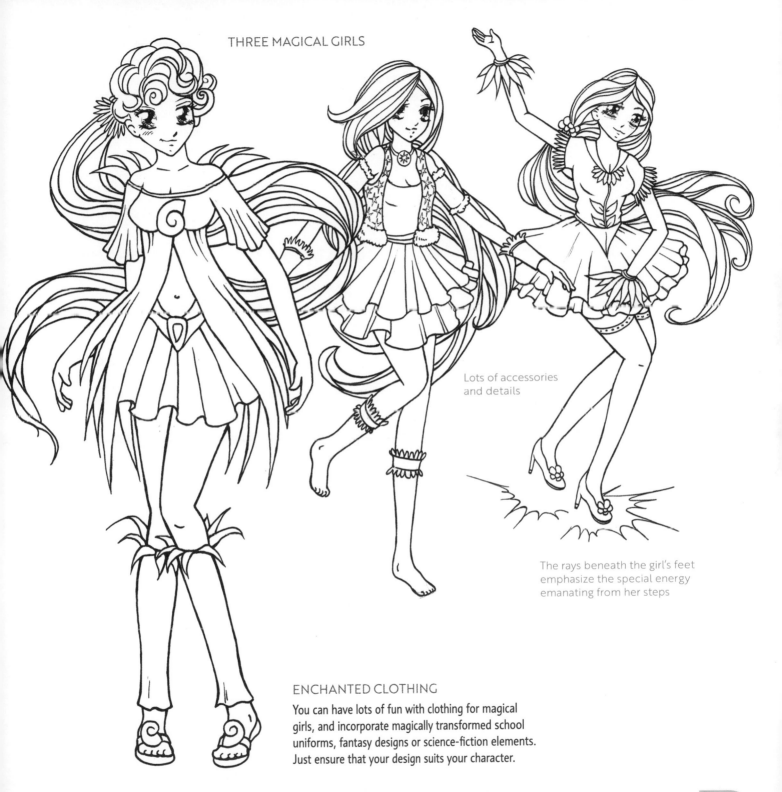

THREE MAGICAL GIRLS

Lots of accessories
and details

The rays beneath the girl's feet
emphasize the special energy
emanating from her steps

ENCHANTED CLOTHING

You can have lots of fun with clothing for magical
girls, and incorporate magically transformed school
uniforms, fantasy designs or science-fiction elements.
Just ensure that your design suits your character.

Limitless emotions

In the previous chapter, we considered how to show the basics of emotions through facial expressions (see pages 32–33). However, in the manga world, depicting emotions means outwardly revealing the complete emotional inner world of a character through typical manga stylistic approaches, in particular making use of the eyes and hair. In manga, everything is experienced more intensely than in reality, and the viewer is inevitably captivated by it.

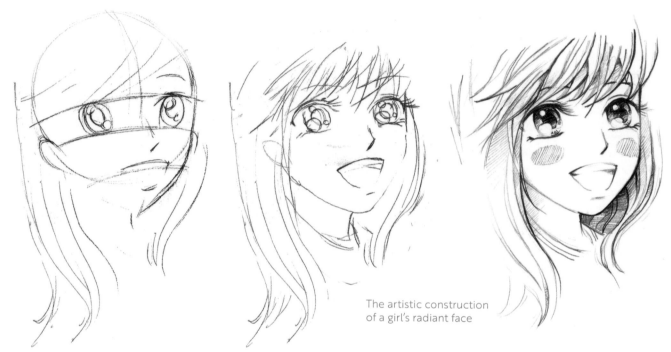

The artistic construction of a girl's radiant face

Desperate girl

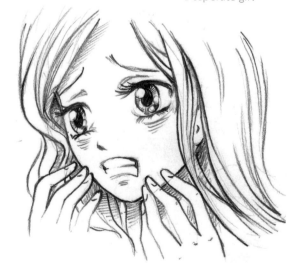

Good to know

Accurately drawing emotions and moods is not easy. It certainly helps to observe people around you or search for reference photos. It is also very helpful to research how other artists have approached the subject. It is perfectly legitimate to learn from them, as long as you don't copy them directly but instead create your own artistic interpretations.

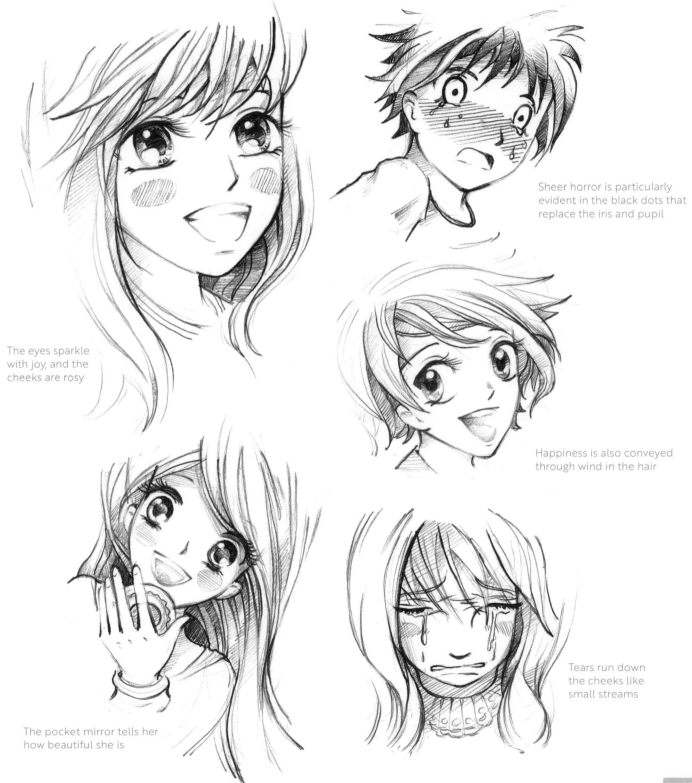

Sheer horror is particularly evident in the black dots that replace the iris and pupil

The eyes sparkle with joy, and the cheeks are rosy

Happiness is also conveyed through wind in the hair

The pocket mirror tells her how beautiful she is

Tears run down the cheeks like small streams

61

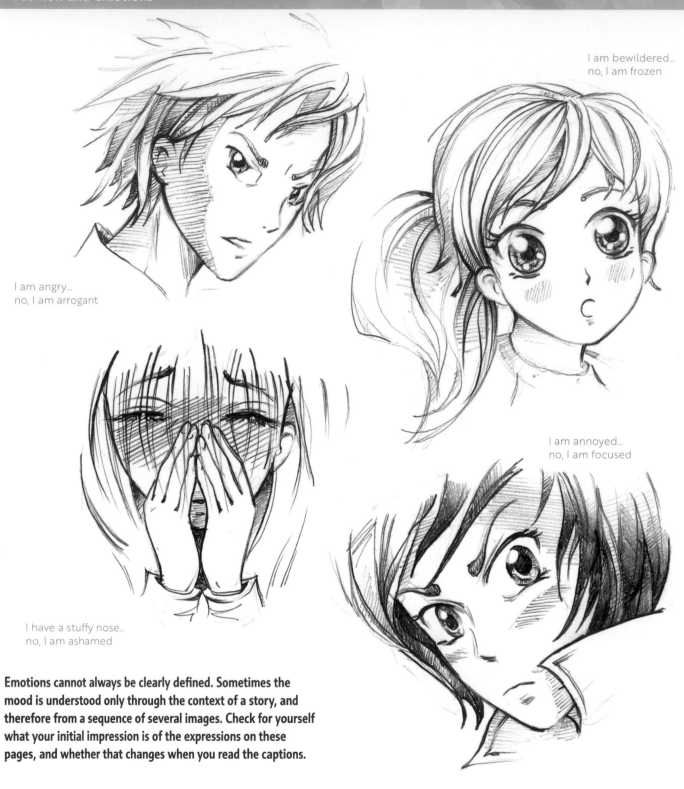

I am bewildered...
no, I am frozen

I am angry...
no, I am arrogant

I am annoyed...
no, I am focused

I have a stuffy nose...
no, I am ashamed

Emotions cannot always be clearly defined. Sometimes the mood is understood only through the context of a story, and therefore from a sequence of several images. Check for yourself what your initial impression is of the expressions on these pages, and whether that changes when you read the captions.

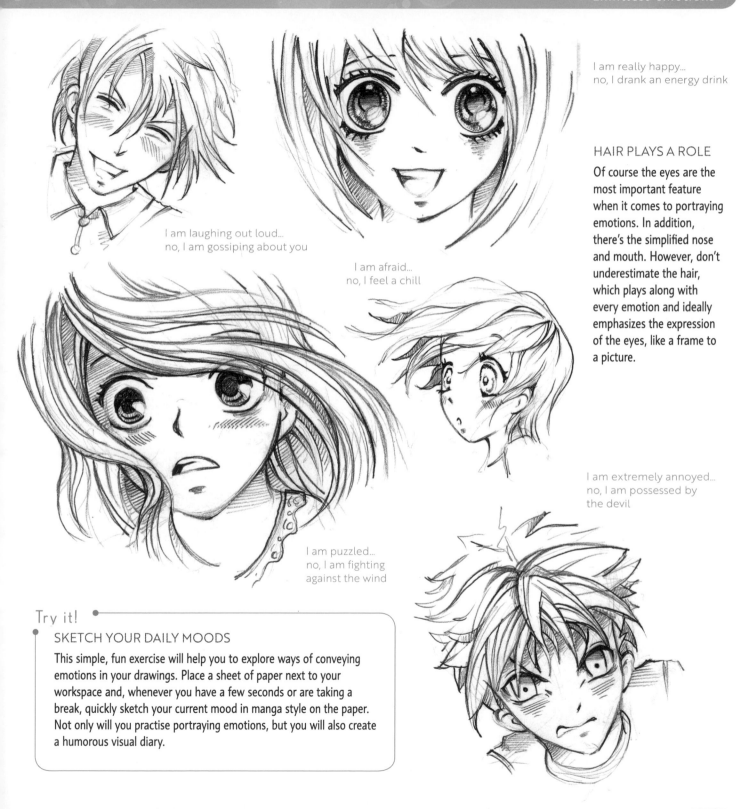

I am laughing out loud...
no, I am gossiping about you

I am really happy...
no, I drank an energy drink

I am afraid...
no, I feel a chill

HAIR PLAYS A ROLE

Of course the eyes are the most important feature when it comes to portraying emotions. In addition, there's the simplified nose and mouth. However, don't underestimate the hair, which plays along with every emotion and ideally emphasizes the expression of the eyes, like a frame to a picture.

I am puzzled...
no, I am fighting against the wind

I am extremely annoyed...
no, I am possessed by the devil

Try it!

SKETCH YOUR DAILY MOODS

This simple, fun exercise will help you to explore ways of conveying emotions in your drawings. Place a sheet of paper next to your workspace and, whenever you have a few seconds or are taking a break, quickly sketch your current mood in manga style on the paper. Not only will you practise portraying emotions, but you will also create a humorous visual diary.

Utterly in love

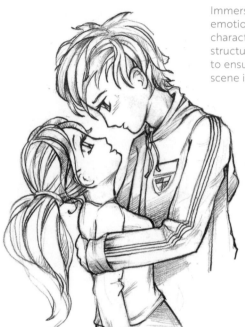

Immerse yourself in the emotional world of both characters from the basic structure stage, in order to ensure the completed scene is believable.

Our feelings are often connected to our relationships with others. A story becomes exciting when emotions erupt and the observer can decide who they feel connected to. In shonen manga there are many emotional fight scenes and sports competitions, but in the popular shojo and bishie stories it is primarily love, jealousy and friendship that determine the course of events. Over the next few pages, let's take the most beautiful emotion, love, as an example.

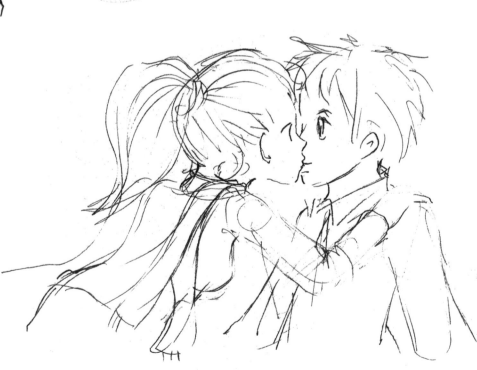

The two gaze directly into each other's eyes

FIRST KISS

In the shojo genre, the ages of the characters can be difficult to estimate. They often appear very childlike and innocent, but there is a 'sweet' aesthetic when the story touches on their experiences of adult emotions, as seen in this kissing motif.

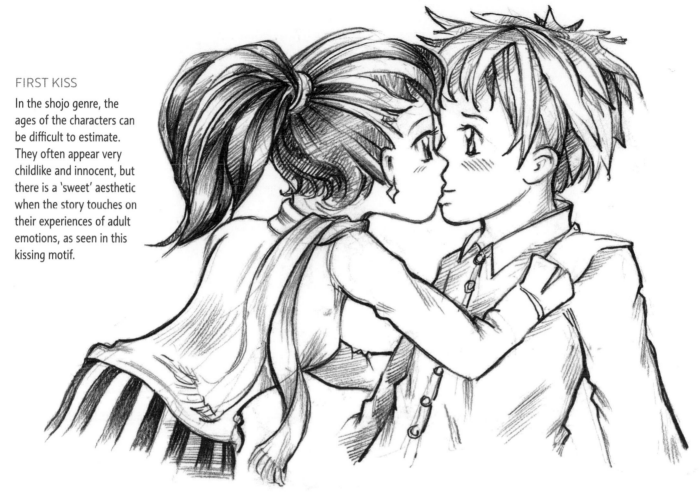

Completed pencil illustration

Details

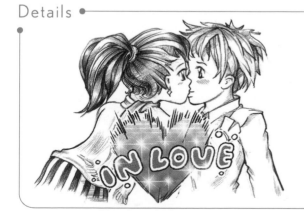

GRAPHIC SYMBOLS

In manga, graphic symbols and words on the image are often used to emphasize a specific situation. In Japanese manga in particular, these symbols may not be easy to understand unless you are familiar with the visual language of the Japanese mangaka. However, there are universal symbols that are understandable anywhere in the world, and in any language.

In this example a heart is added to the illustration and emblazoned with words that emphasize the emotions of the scene.

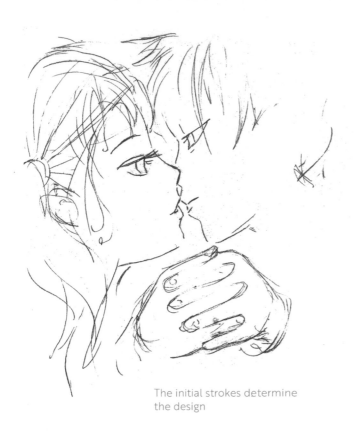

The initial strokes determine the design

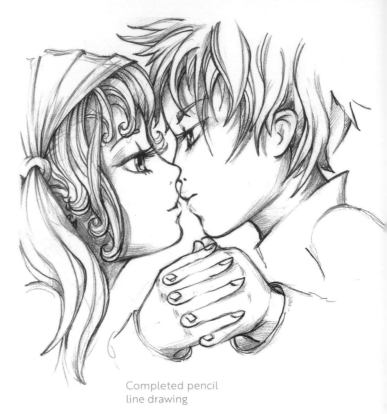

Completed pencil line drawing

First step in shading with hatched lines

When two people who like each other meet, it is an exciting moment when their lips touch for the first time. Because in that moment, everything changes: friendship turns into love, and two single people become a couple. Life itself can be transformed in that tiny moment, depending on what develops from the partnership. That's why it is such a frequently depicted moment, especially in films. From a drawing perspective, it is much more challenging, because instead of a long film sequence, you have only a few lines with which to convey the full power of the emotions involved.

Details

LOVE IN THE MANGA WORLD

Just as in real life, the theme of love has evolved over time in the manga world. While the typical clichés and gender roles still exist (as shown here), there is also representation of homosexual love or love for fantasy creatures.

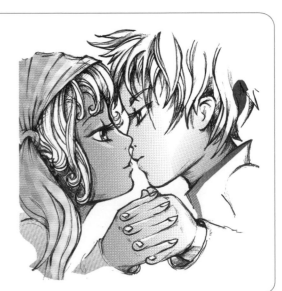

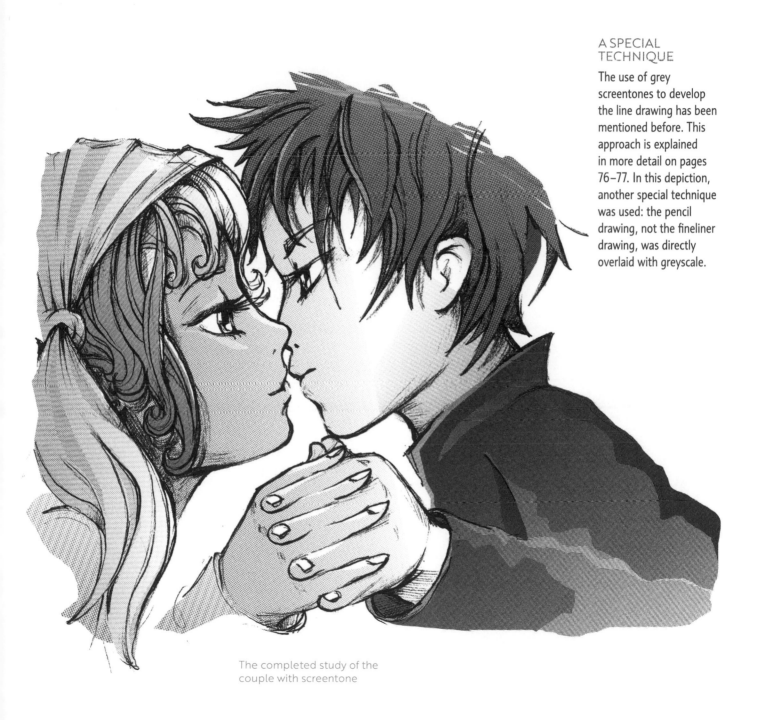

The completed study of the
couple with screentone

A SPECIAL TECHNIQUE

The use of grey
screentones to develop
the line drawing has been
mentioned before. This
approach is explained
in more detail on pages
76–77. In this depiction,
another special technique
was used: the pencil
drawing, not the fineliner
drawing, was directly
overlaid with greyscale.

Enchanting faces from other worlds

Character from a science-fiction story

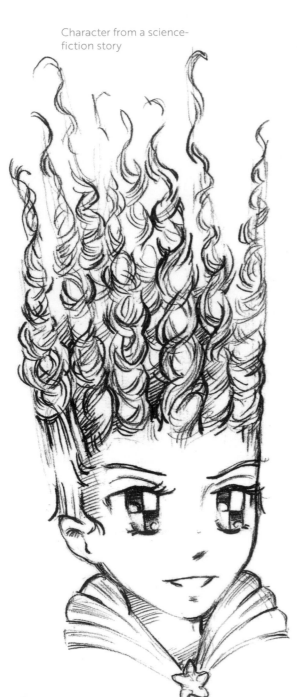

On pages 58–59 on magical transformations, we touched on the techniques for turning ordinary schoolgirls into heroes with special abilities. This theme is revisited here to show that there are diverse possibilities existing across genres, and that designing fashion beyond the real world can be great fun.

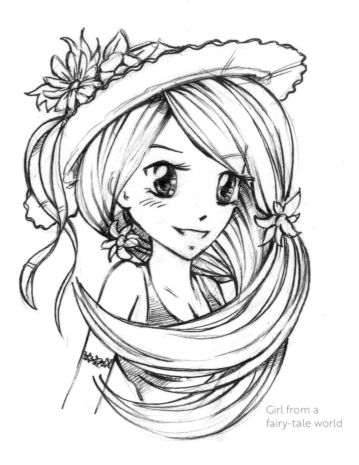

Girl from a fairy-tale world

FASHION CONTRASTS

Featured on this page are two very different characters. The futuristic girl on the left has an extreme upright hairstyle and chessboard eyes, while the flower girl on the right has lush, flowing hair. Even when designing eyes, you can explore entirely new avenues.

Face with animal-like elements and futuristic features

Digitally-coloured fantasy princess

Typical magical-girl hair

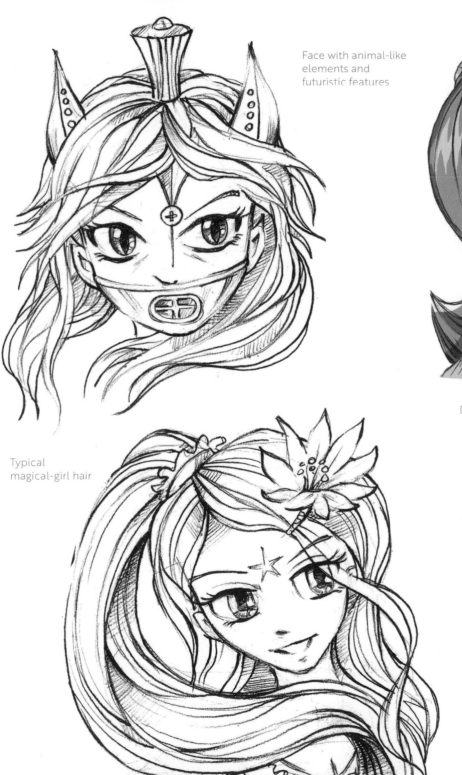

Good to know

The term 'genre' (derived from the French word for type) refers to a classification used to categorize different directions in art and literature based on when and where the scene is set. Examples in manga include shojo stories or shonen adventures, which can be further classified into subgenres such as mystery, horror, fantasy, science fiction or magical girls.

Valuable knowledge

Any endeavour, no matter how enjoyable, involves learning and honing one's skills, which might feel onerous. This of course applies to drawing. However, it's important to really get to know the principles and practices of your art; in doing so, you will soon be able to broaden your horizons and be open to entirely new creative possibilities. You will find some valuable knowledge in the following pages.

Give it a try, and you'll see that both practice, and acquiring knowledge, can be really enjoyable.

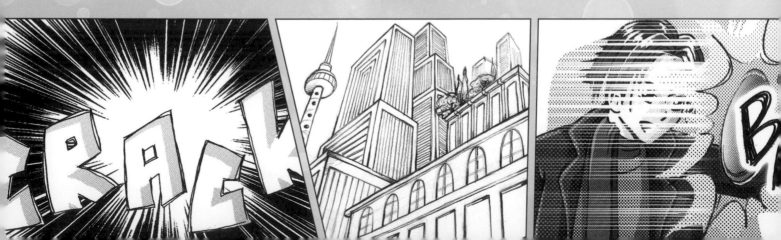

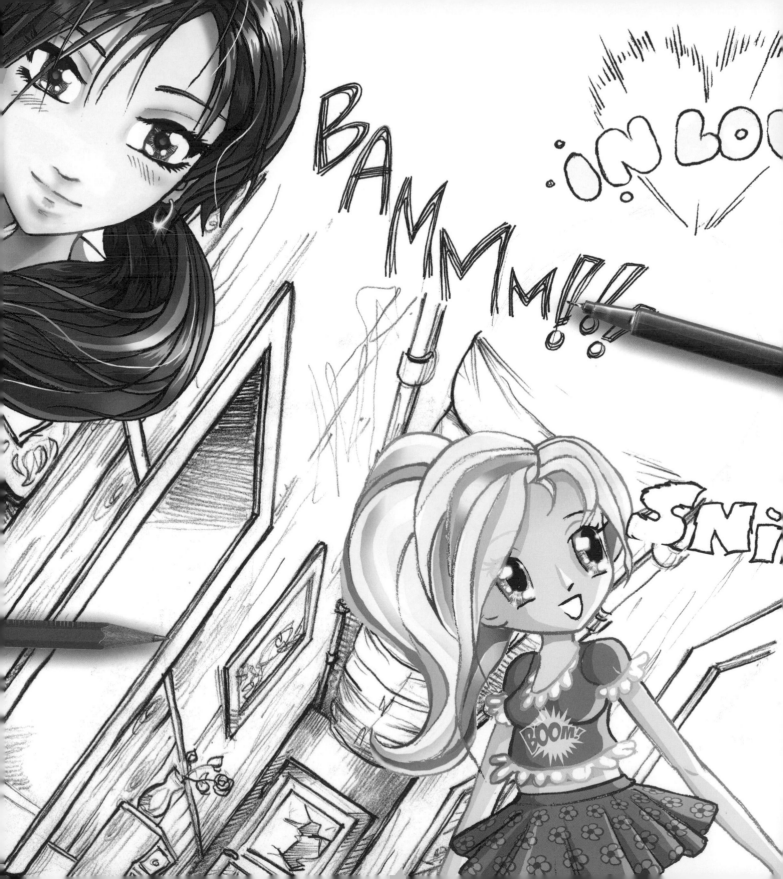

Perspective

Perspective drawing is a fundamental lesson for any artist, but it's important to differentiate between different forms of perspective. For artistic drawing such as for manga, basic knowledge and the experience gained through practice are usually sufficient.

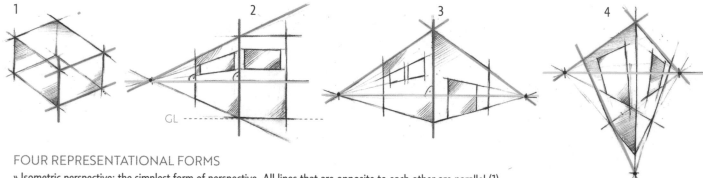

FOUR REPRESENTATIONAL FORMS

» Isometric perspective: the simplest form of perspective. All lines that are opposite to each other are parallel (1).

» One-point perspective: all lines that recede converge at a single point on the horizon. Vertical lines remain vertical, and horizontal lines remain horizontal on the ground line (GL) and lines parallel to it (2).

» Two-point perspective: all lines that recede converge at two points on the horizon. Only vertical lines remain vertical (3).

» Three-point perspective: all lines that recede converge at two points on the horizon. 'Vertical' lines converge at a point above or below the horizon (4).

INTERIOR VIEW

This example demonstrates the application of perspective in depicting a hallway. If you follow the lines on the floor, walls and ceiling, you'll see that they converge roughly at a point just below the broken pane of the farthest door. Therefore, the drawing is executed in one-point perspective. Sometimes, it's good if the perspective isn't entirely perfect. It adds liveliness to the drawing, compared with a more accurate, constructed drawing.

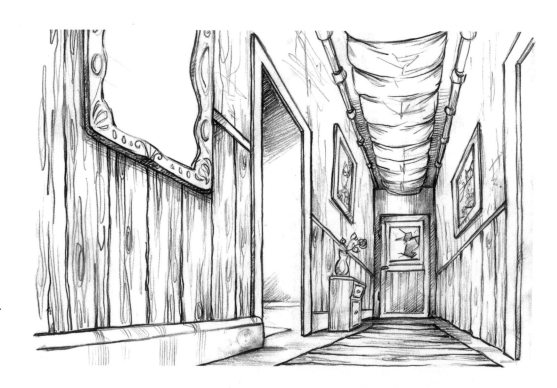

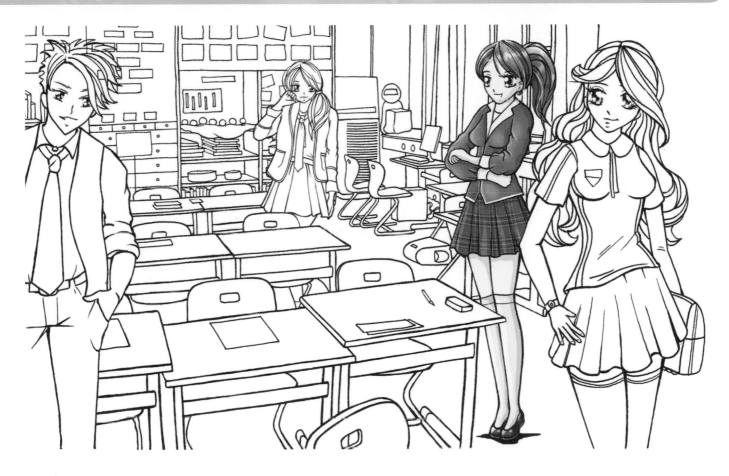

THE CLASSROOM

Drawing a space with plenty of detail, like this classroom, is time-consuming and requires plenty of patience. You can achieve a good result much faster by tracing a reference photo instead.

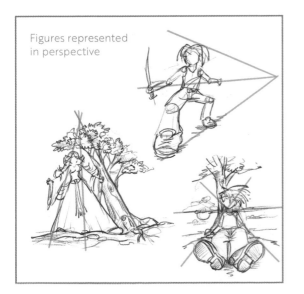

Figures represented in perspective

Good to know

Once you've chosen a perspective variation, it needs to be applied to all elements of the image. The small images on the left show characters in extreme perspective, including a lady by a tree and a boy sitting in front of a tree stump. In architectural representations, incorrect perspective is immediately noticeable, whereas it's easier to depict plants since their wild growth does not follow right angles.

Backgrounds

Drawing spaces, backgrounds and landscapes is not as important in manga as in other art forms, since the focus is on the characters and their faces. However, there are still scenes that require backgrounds. On these pages you can see three examples of backgrounds that encompass varying levels of difficulty, and in which perspective has been used in very different ways.

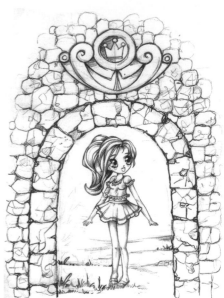

The front view of the archway does not require the use of perspective

CITYSCAPE

In this worm's-eye view of characters in front of skyscrapers you can see the application of three-point perspective. The angle of view exaggerates the towering nature of the buildings.

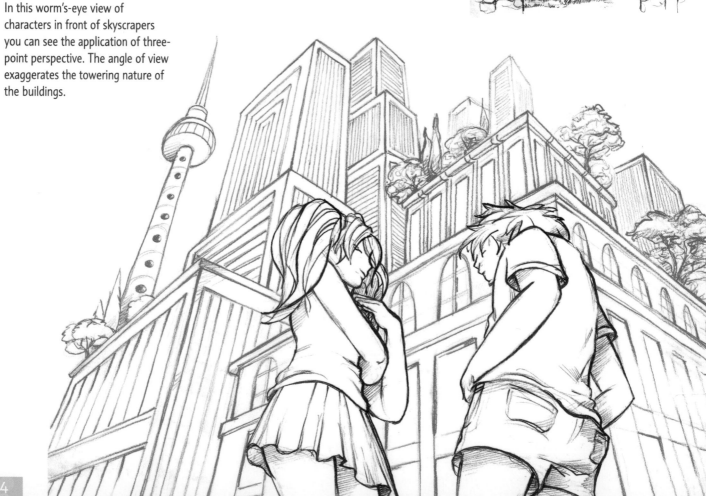

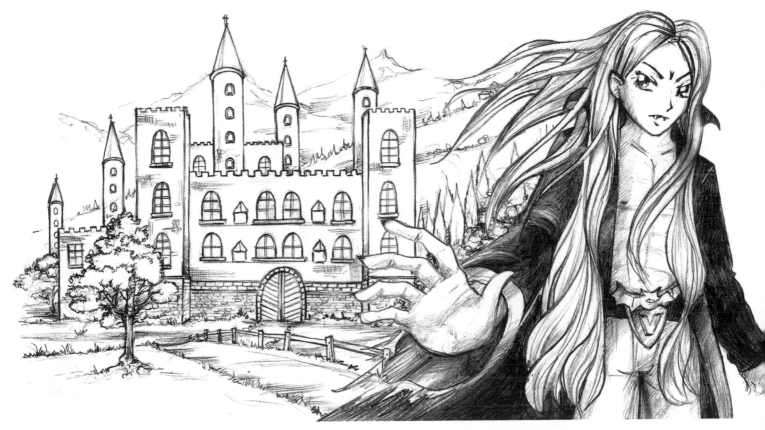

In this case, one-point perspective is applied to the narrow sides of the square towers, and the path is widened in perspective as it moves towards the viewer

Details

A DEMANDING APPROACH

Cityscapes on a page look spectacular, but you need patience to draw them this accurately, and a large sheet of paper to include all three vanishing points – the blue lines show the vanishing lines of the three-point perspective. You also need to make sure the windows, roof overhangs, doors and other building elements all align with the perspective's vanishing lines. If one line is wrong, the whole drawing will look odd.

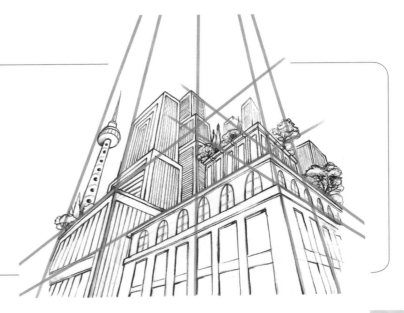

Digital colouring

There are many digital tools for colouring your manga drawings, and a comprehensive discussion of all of them would go beyond the scope of this drawing course. However, you can find additional literature on each technique.

The following four pages provide an overview of the most important techniques, and serve as a starting point for your own exploration into digital colouring techniques.

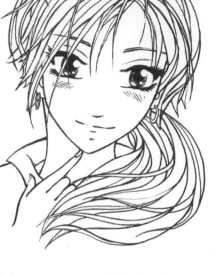

Basic drawing of a girl's head

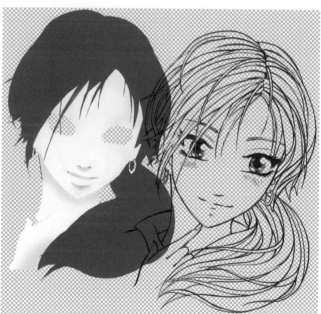

Digitally coloured completed illustration

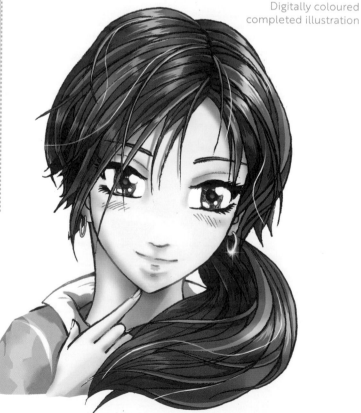

WORK IN LAYERS

The digital tools in popular programs such as Photoshop, GIMP or CorelDRAW are comparable to traditional tools such as pens, erasers and scissors, but with a much greater scope in their possibilities. The major advantage of working on the computer is the ability to work on different layers, separating the line art from the colours. This allows you to make changes to even the smallest elements at any time.

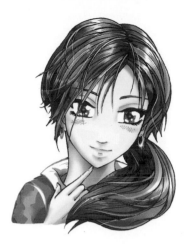
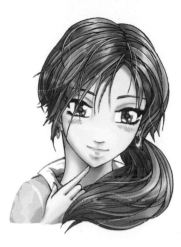
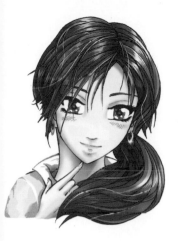

COLOUR VARIATIONS

Digital colouring makes it easy to try different colour variations, and you can undo steps if you make a mistake or don't like the result.

WORKING WITH SCREENTONES

Using screentones is a typical shading technique in manga art, and involves incorporating gridded greyscales and textures into the drawing. The digital process is similar to colouring techniques.

Screentone shading

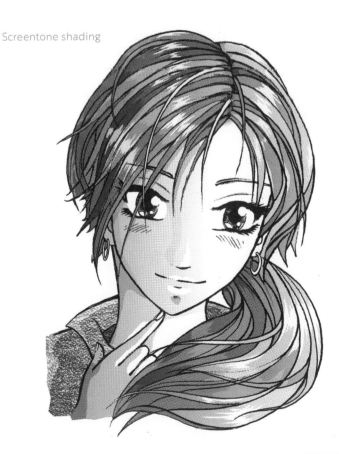

Details •

SCREENTONES BY HAND

Screentones can also be bought as a physical product, with the pattern printed on transparent adhesive film. Cut a piece of the film to the required size and gently stick it to the drawing. Then cut along the desired line on the film without cutting through the drawing. Lift off the excess. Finally, firmly press the film onto the paper to make sure it adheres properly. When you make photocopies, everything comes together.

Colouring by hand

Colouring by hand allows for a very individual style to be expressed, and even though almost everyone has a smartphone, tablet, computer or all of these, many artists prefer to draw and colour by hand. When it comes to manga, fineliners and markers, sometimes combined with coloured pencils, are very popular materials.

This step-by-step demonstration explains the process.

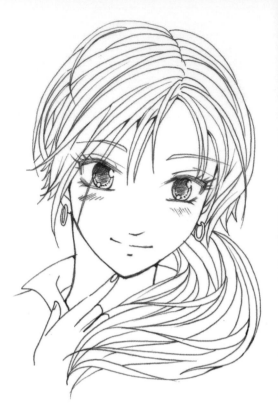

STEP 1

Draw the outlines with a smudge-resistant, non-soluble marker.

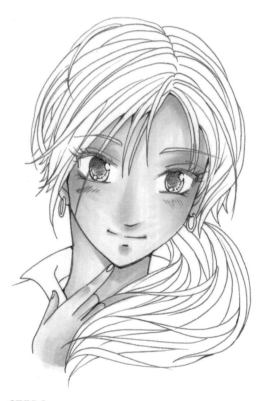

STEP 2

Always work from light to dark, so that the colour doesn't smudge. Start with the lightest marker, then gradually move to darker shades.

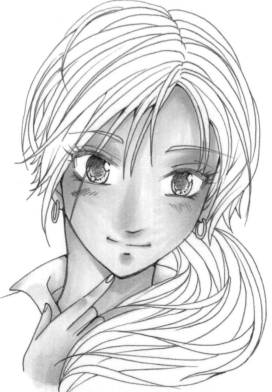

STEP 3

Grey can be used to add shading to areas of white.

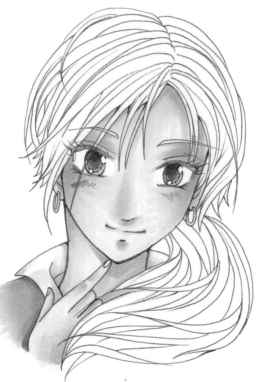

STEP 4
Colour the eyes and the shirt, again working from light to dark.

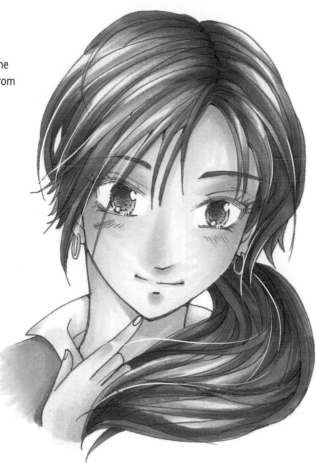

STEP 6
Add the final highlights with a white pen. You can see them here in the eyes and hair. Similar effects can be achieved with a white gel roller.

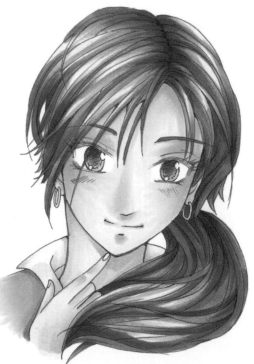

STEP 5
Colour the hair from light to dark, leaving white highlights in places.

Graphic symbols and effects

Using graphic symbols and words to indicate sound effects is popular in manga art, as well as in comics in general. They serve to make a specific situation in the image more impactful. Artists develop their own visual language for this creative second layer of information over time.

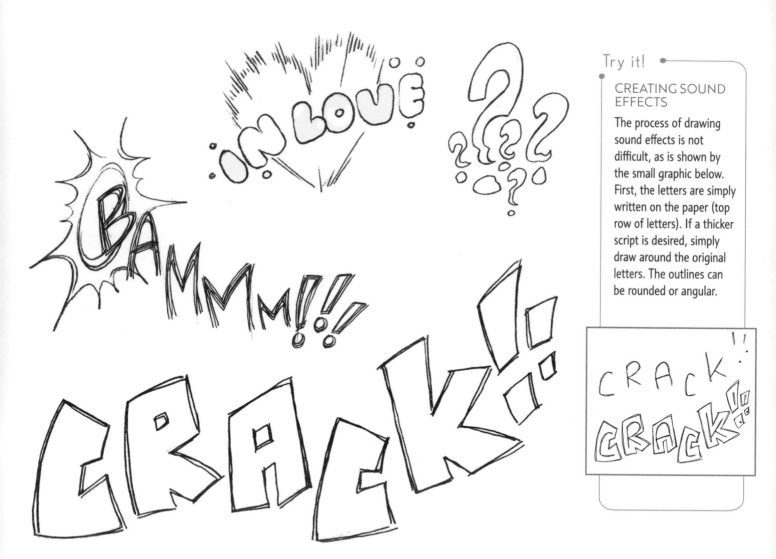

Try it!

CREATING SOUND EFFECTS

The process of drawing sound effects is not difficult, as is shown by the small graphic below. First, the letters are simply written on the paper (top row of letters). If a thicker script is desired, simply draw around the original letters. The outlines can be rounded or angular.

SOUND EFFECTS

Sound-effect words can be complemented by small graphics, such as the heart and explosion drawn here.

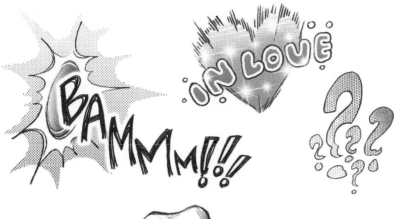

REFINEMENT

Words and symbols in the typical manga style can be shaded in grey or gradations to create a more three-dimensional effect.

For the monster illustration below left, three graphical techniques have been added to convey the full impact of the creature's action:

1. The rays, symbolizing the explosive breaking through;
2. The onomatopoeic text CRACK!!;
3. The perspective of the figure, with the vanishing point located below the ground.

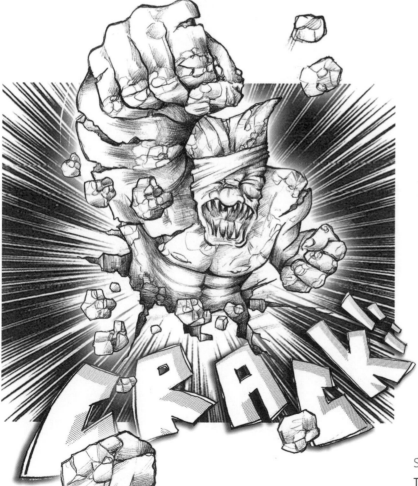

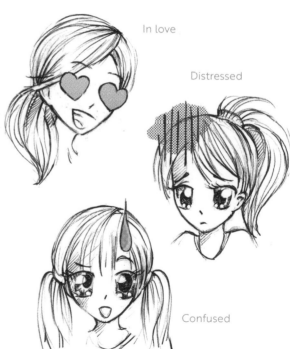

In love

Distressed

Confused

SMALL SYMBOLS WITH BIG MEANING

The above faces illustrate some typical manga symbols and their meaning in depicting emotions.

It's all cute

Alongside the main characters, other beings appear in manga stories, such as little friends and helpers who accompany the heroes on their adventures. In real-life stories, they could be pets; in fantasy worlds, they might be magical creatures or living dolls or toys. These beings are often incredibly cute, so adorable that you just want to hug them.

Sometimes it's the manga characters themselves who are super cute, such as chibis, the little heroes with the big heads and boundless energy.

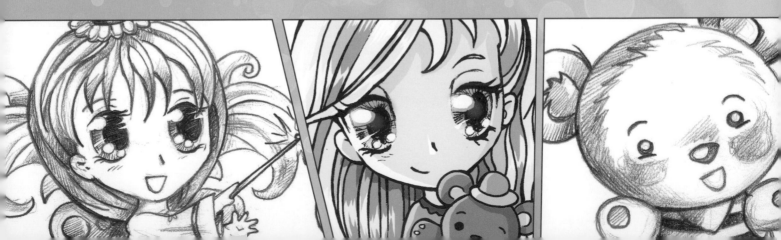

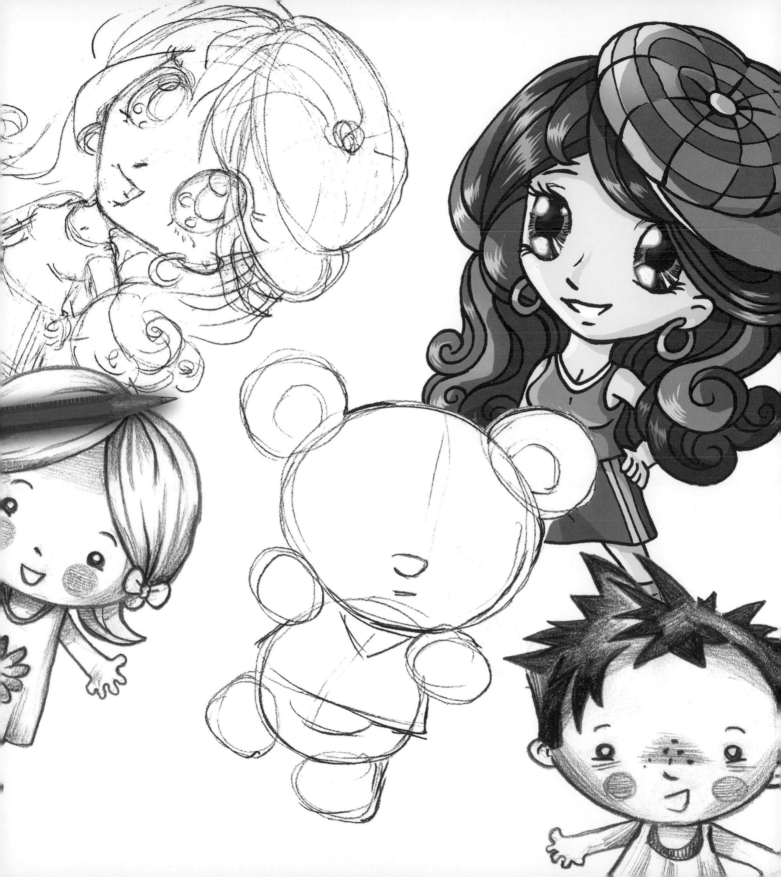

The world of chibis

Having probably drawn lots of shojos by now, you might be ready for a different challenge. If you are keen to dive into other worlds, draw one or more chibi characters and imagine what their home environment might look like. These funny characters with big heads are perfect for developing stories, since they can take any form and live in any environment. You just have to bring them to life!

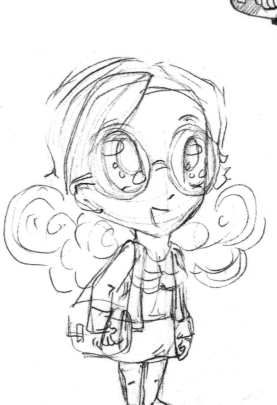

Develop the basic structure further and add details

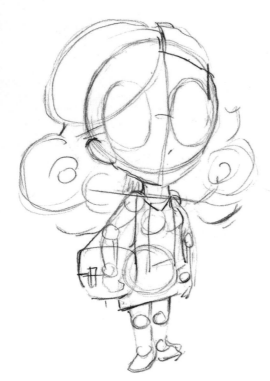

Completed pencil drawing: the thick glasses really enhance the eyes

BUSY CHIBI

It's easy to imagine chibis whizzing around, bustling and busy. With the glasses, outfit and bag, this chibi girl could be a businesswoman, teacher or student.

Start with basic shapes and circle joints, as we have been doing with our characters so far

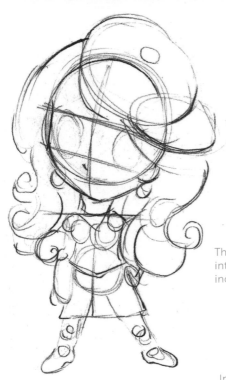

CITY GIRL

This chibi girl is confident and fashionable. You can easily imagine her shopping in a European or Asian metropolis.

The initial strokes already take into account the accessories, including the hat and bag

In the second step, you can see the details in the hair, eyes and clothing

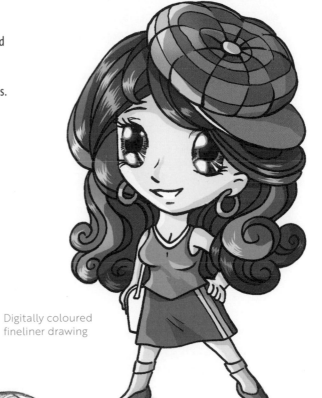

Digitally coloured fineliner drawing

STYLISH COLOURING

To stand out in a big city, a special look is needed, which includes an artist's clever choice of colours.

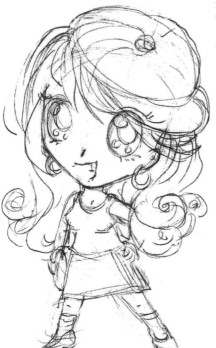

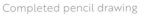

Completed pencil drawing

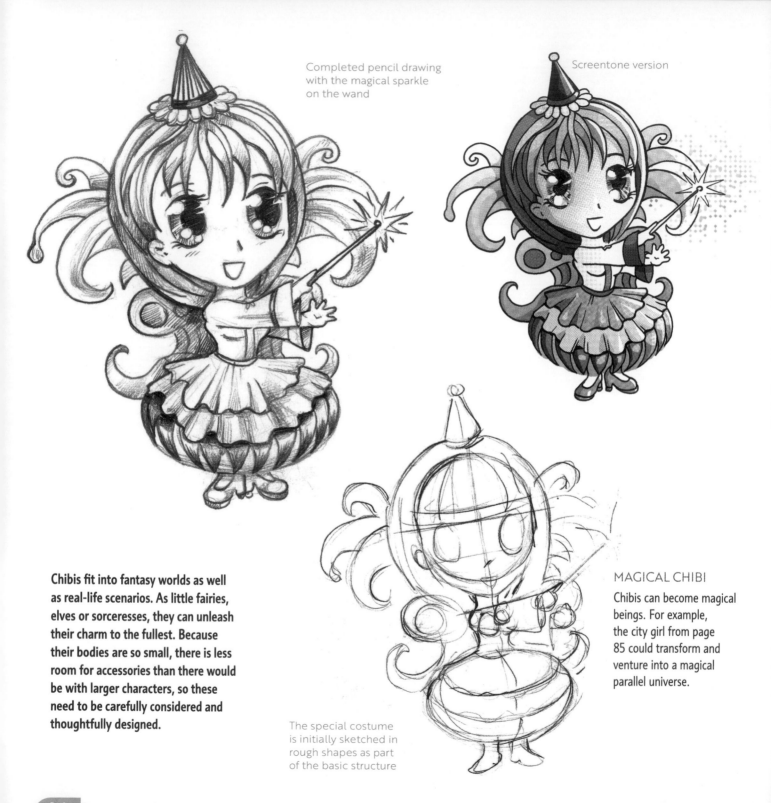

Completed pencil drawing
with the magical sparkle
on the wand

Screentone version

Chibis fit into fantasy worlds as well
as real-life scenarios. As little fairies,
elves or sorceresses, they can unleash
their charm to the fullest. Because
their bodies are so small, there is less
room for accessories than there would
be with larger characters, so these
need to be carefully considered and
thoughtfully designed.

MAGICAL CHIBI

Chibis can become magical
beings. For example,
the city girl from page
85 could transform and
venture into a magical
parallel universe.

The special costume
is initially sketched in
rough shapes as part
of the basic structure

CUTE MEETS CUTE

This image already hints at the theme of stuffed animals and dolls as manga companions, because it combines two adorable elements in one illustration: the chibi girl in pyjamas and the teddy bear with a hat.

Basic structure for the girl and the teddy bear

Completed pencil drawing

Good to know

When it comes to drawing, the term 'cute' often equates to delicate. That's why chibis don't have big, bulky hands or feet; quite the opposite. However, their eyes are depicted as even bigger than usual in relation to the head, and they are shinier too.

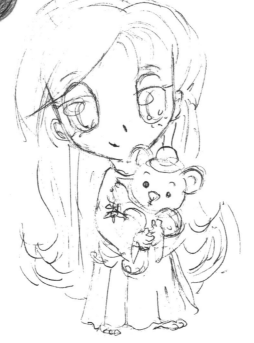

This detailed sketch already takes into account the highlights in the eyes

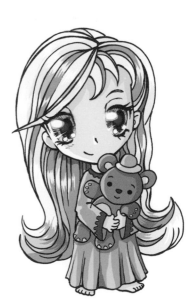

Digitally coloured fineliner drawing

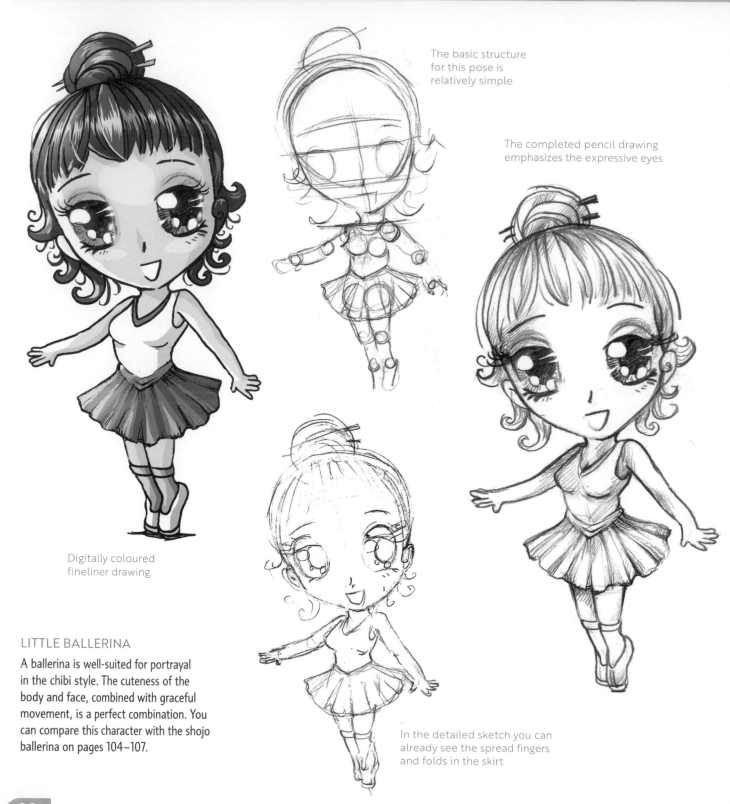

The basic structure for this pose is relatively simple

The completed pencil drawing emphasizes the expressive eyes

Digitally coloured fineliner drawing

LITTLE BALLERINA

A ballerina is well-suited for portrayal in the chibi style. The cuteness of the body and face, combined with graceful movement, is a perfect combination. You can compare this character with the shojo ballerina on pages 104–107.

In the detailed sketch you can already see the spread fingers and folds in the skirt

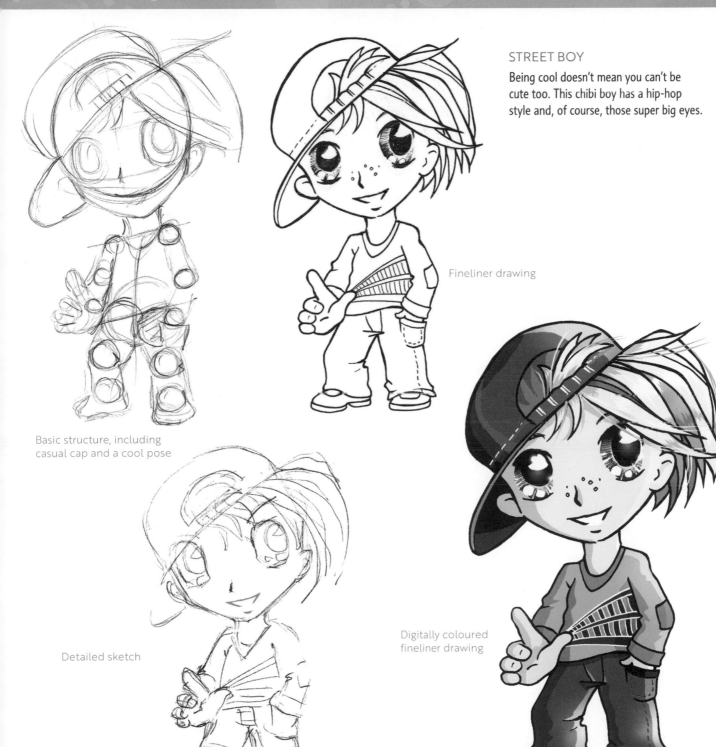

STREET BOY

Being cool doesn't mean you can't be cute too. This chibi boy has a hip-hop style and, of course, those super big eyes.

Fineliner drawing

Basic structure, including casual cap and a cool pose

Detailed sketch

Digitally coloured fineliner drawing

Shojo or chibi... or both?

This is a question that many artists struggle with, unsure of whether they want to draw in the chibi style or shojo. The answer is quite simple. There is no right or wrong choice. In the following step sequence you will learn how to draw a character that deliberately lies somewhere between a shojo and chibi, to show that there are many forms of manga expression, and that an artist is not bound by strict stylistic rules. Art is individual, so don't be afraid to develop your own style!

Good to know

The two illustrations show the same girl drawn to different proportions.

Is the little girl now a chibi or still a shojo? Or is the big girl a shojo or already a teen girl? The decision is left to the viewer. The important thing is this: you have freedom of artistic expression. Don't let yourself be confined to a box, but create according to your own taste. That's usually when it turns out best.

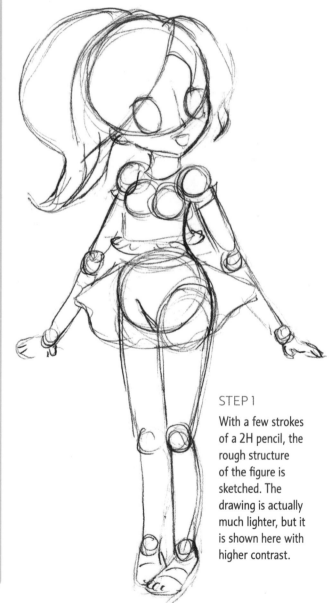

Is she a shojo or a chibi? It doesn't matter: maybe she's something completely different. The main thing is that it's manga and it's fun!

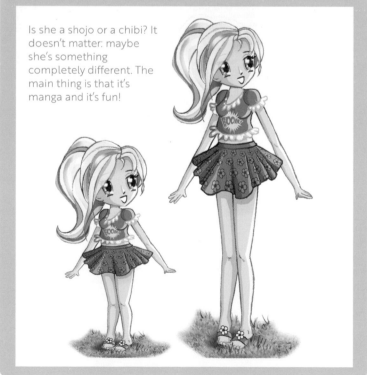

STEP 1

With a few strokes of a 2H pencil, the rough structure of the figure is sketched. The drawing is actually much lighter, but it is shown here with higher contrast.

On this and the following two pages, all the design processes are shown step by step using the little girl with the ponytail. The colouring is rendered digitally and provides some additional information on working with graphic software.

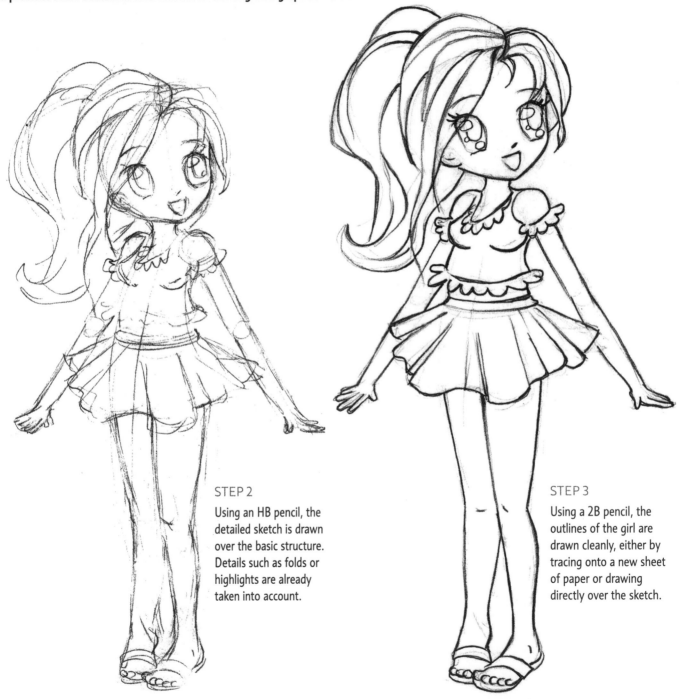

STEP 2

Using an HB pencil, the detailed sketch is drawn over the basic structure. Details such as folds or highlights are already taken into account.

STEP 3

Using a 2B pencil, the outlines of the girl are drawn cleanly, either by tracing onto a new sheet of paper or drawing directly over the sketch.

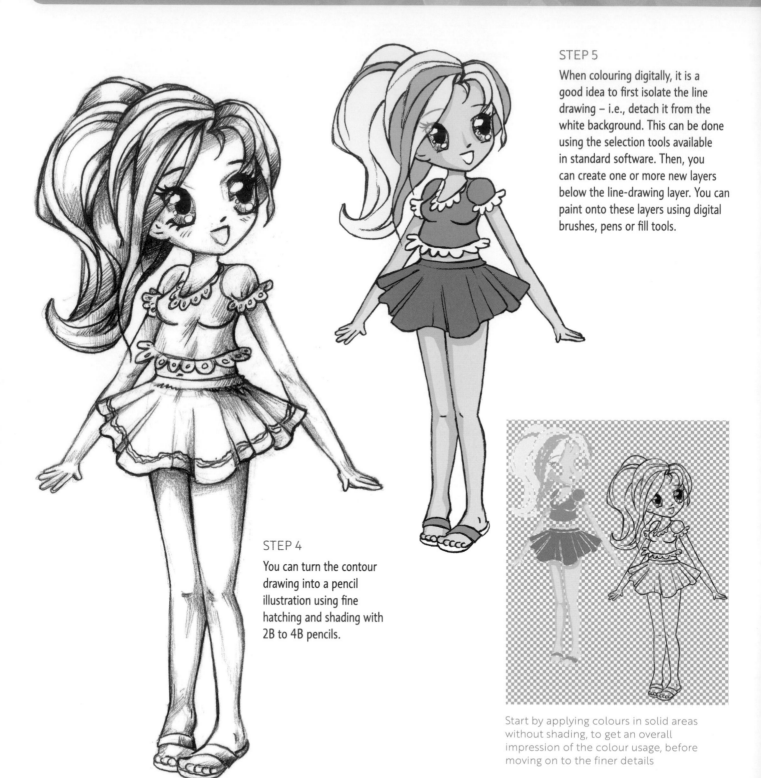

STEP 5

When colouring digitally, it is a good idea to first isolate the line drawing – i.e., detach it from the white background. This can be done using the selection tools available in standard software. Then, you can create one or more new layers below the line-drawing layer. You can paint onto these layers using digital brushes, pens or fill tools.

STEP 4

You can turn the contour drawing into a pencil illustration using fine hatching and shading with 2B to 4B pencils.

Start by applying colours in solid areas without shading, to get an overall impression of the colour usage, before moving on to the finer details

STEP 6

Once the large coloured spaces have been applied, you can start with the fine work. Digital software programs offer airbrush or other shading options. The text on the T-shirt and flowers on the skirt are taken from a digital image library within the program.

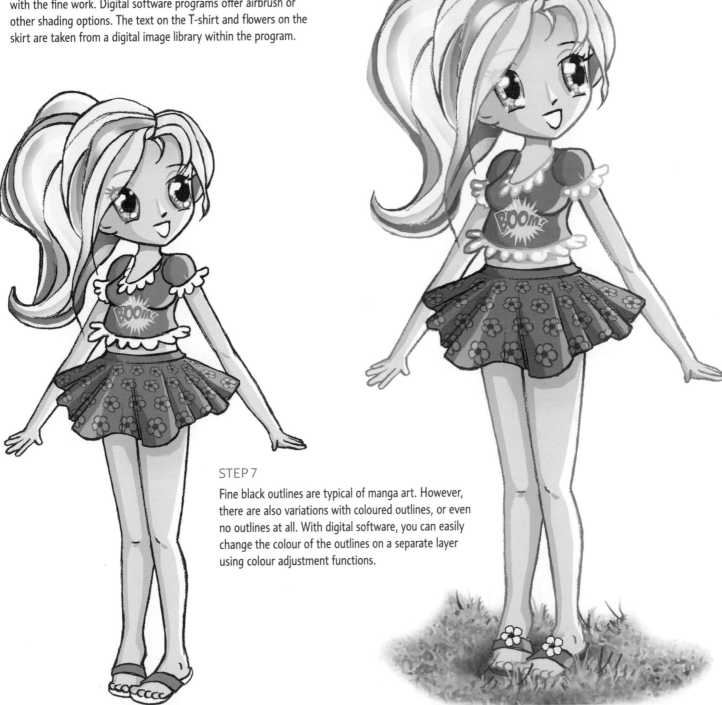

STEP 7

Fine black outlines are typical of manga art. However, there are also variations with coloured outlines, or even no outlines at all. With digital software, you can easily change the colour of the outlines on a separate layer using colour adjustment functions.

Dolls and stuffed animals

It's common to see the main protagonists of manga stories carrying something with them. As well as pets, these can be dolls, stuffed animals, lucky charms, pouches or even mysterious items.

What stands out is that dolls or cuddly toys do not have the typical large manga eyes, but rather tiny button eyes and simplified noses, arms or legs.

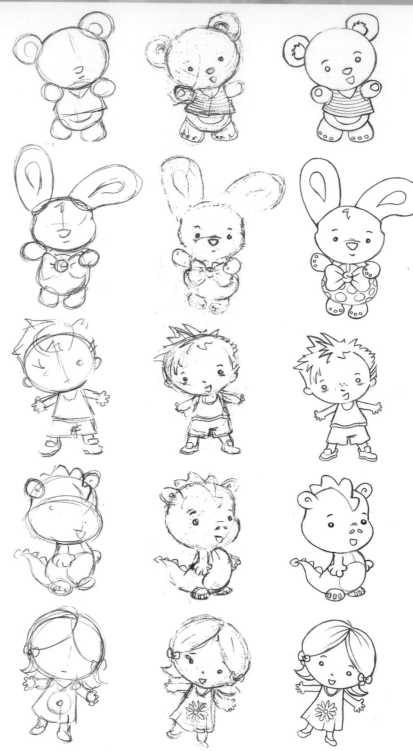

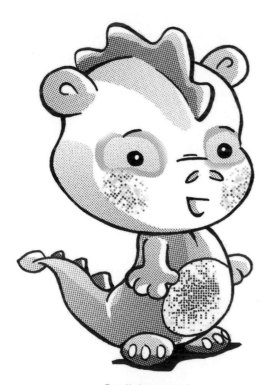

Small dragon with screentone shading

A collection of cuddly dolls from basic drawing structure to line drawing

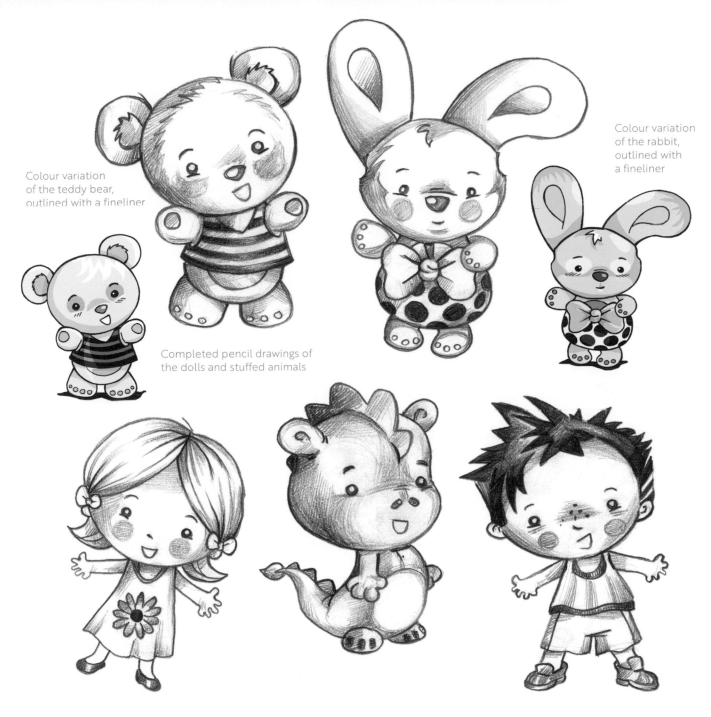

Colour variation of the teddy bear, outlined with a fineliner

Colour variation of the rabbit, outlined with a fineliner

Completed pencil drawings of the dolls and stuffed animals

COMPARISON

These toys are comparable in proportion to chibis; however, unlike chibis, they don't have large, shiny eyes, but instead have highly simplified, minimalist faces.

My own manga

Are you ready for the next big step? Now you're diving into the lessons that have led to countless pencils being sharpened down to stubs, and lots of time spent with fineliners, markers or digital tech. And let's not forget about the friends who always wonder why your fingers are so colourful. Well, that's the result of spending hours at the drawing board with fineliners and markers, battling to achieve the maximum expression in your characters.

In this chapter, you'll learn how to bring action to your characters and, most importantly, how to create your own manga story. Let's get started...

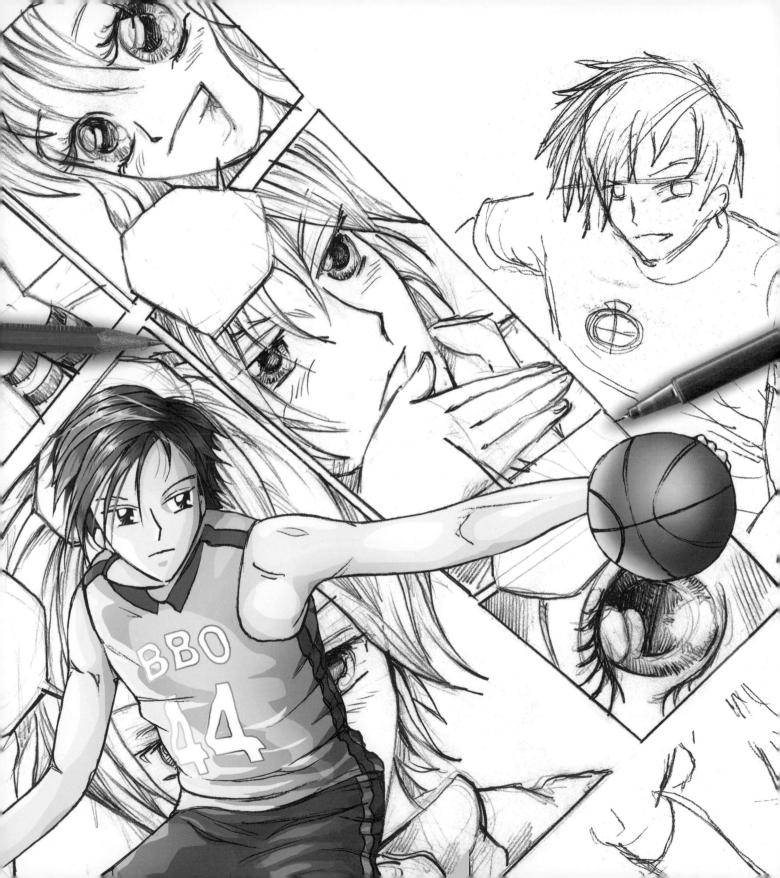

Bringing in the action

This is a most exciting lesson, but also a challenging one, because it teaches you how to depict your heroes in real action poses. While we have already learned about the fundamentals of manga movement and perspective – even though the figures were still drawn statically – now, it's time to infuse true dynamism into your characters' movements, allowing the viewer to feel fully immersed in the action.

Good to know

An action line indicates the direction of movement, and can be represented by a single dynamic line, just like the coloured lines on this page. If you think the poses on the right look too challenging, you can practise with much simpler figures, as shown below.

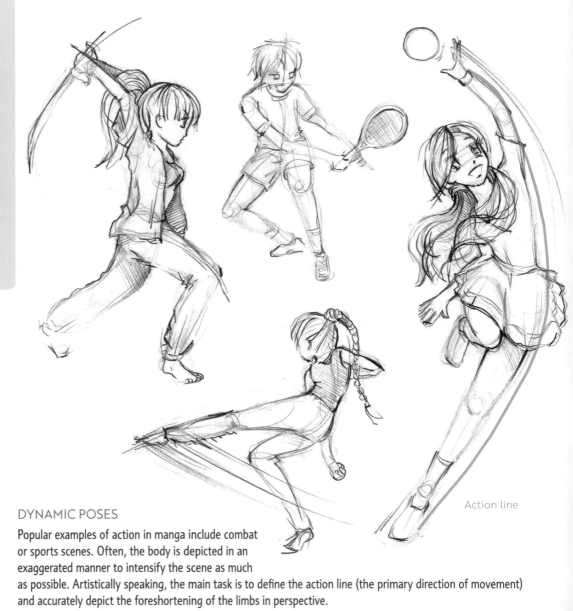

Action line

DYNAMIC POSES

Popular examples of action in manga include combat or sports scenes. Often, the body is depicted in an exaggerated manner to intensify the scene as much as possible. Artistically speaking, the main task is to define the action line (the primary direction of movement) and accurately depict the foreshortening of the limbs in perspective.

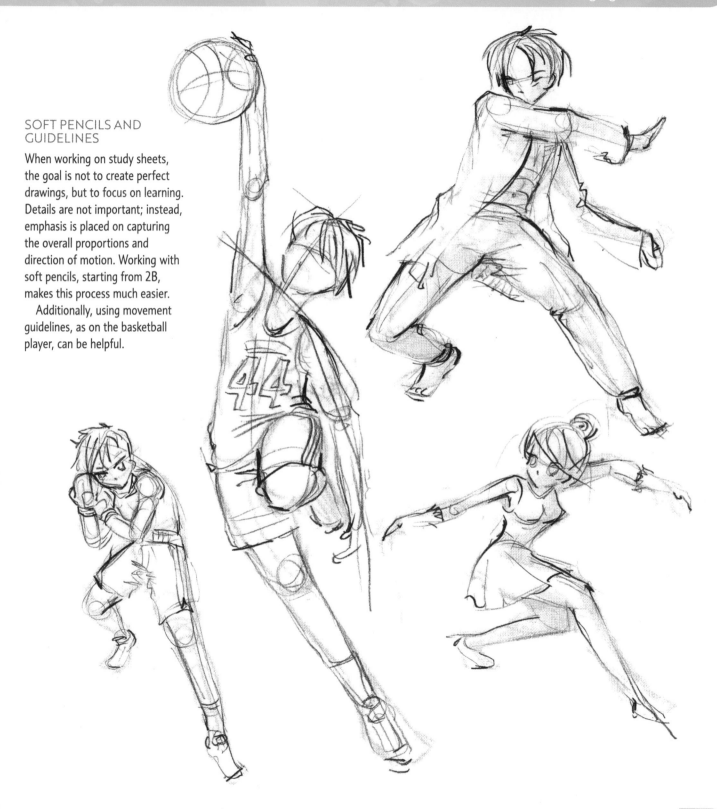

SOFT PENCILS AND GUIDELINES

When working on study sheets, the goal is not to create perfect drawings, but to focus on learning. Details are not important; instead, emphasis is placed on capturing the overall proportions and direction of motion. Working with soft pencils, starting from 2B, makes this process much easier.

Additionally, using movement guidelines, as on the basketball player, can be helpful.

Young gun

Over the following pages, using four characters as examples, we will demonstrate various techniques to create action-packed poses. Let's start with a simple figure that has minimal movement but is suitable for showcasing sequential movements across multiple frames.

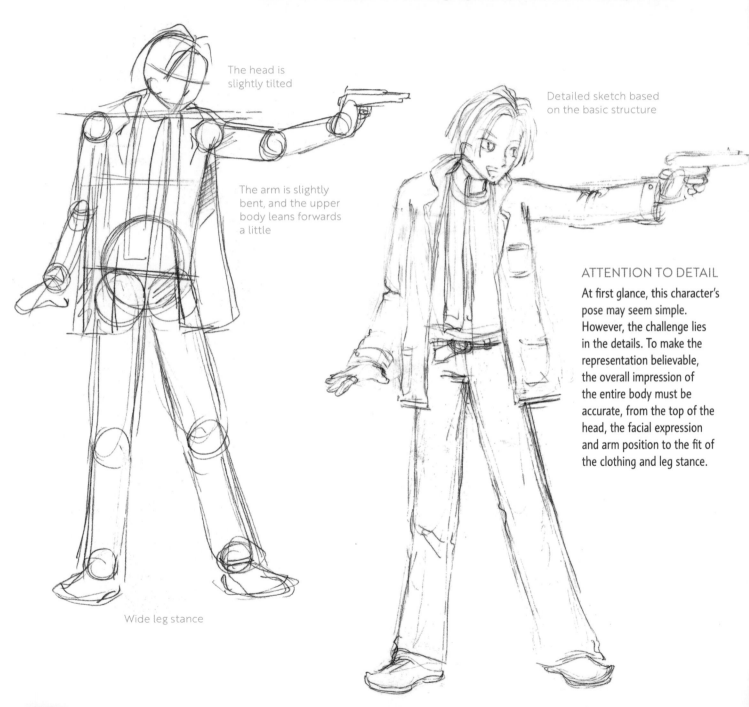

The head is slightly tilted

The arm is slightly bent, and the upper body leans forwards a little

Wide leg stance

Detailed sketch based on the basic structure

ATTENTION TO DETAIL

At first glance, this character's pose may seem simple. However, the challenge lies in the details. To make the representation believable, the overall impression of the entire body must be accurate, from the top of the head, the facial expression and arm position to the fit of the clothing and leg stance.

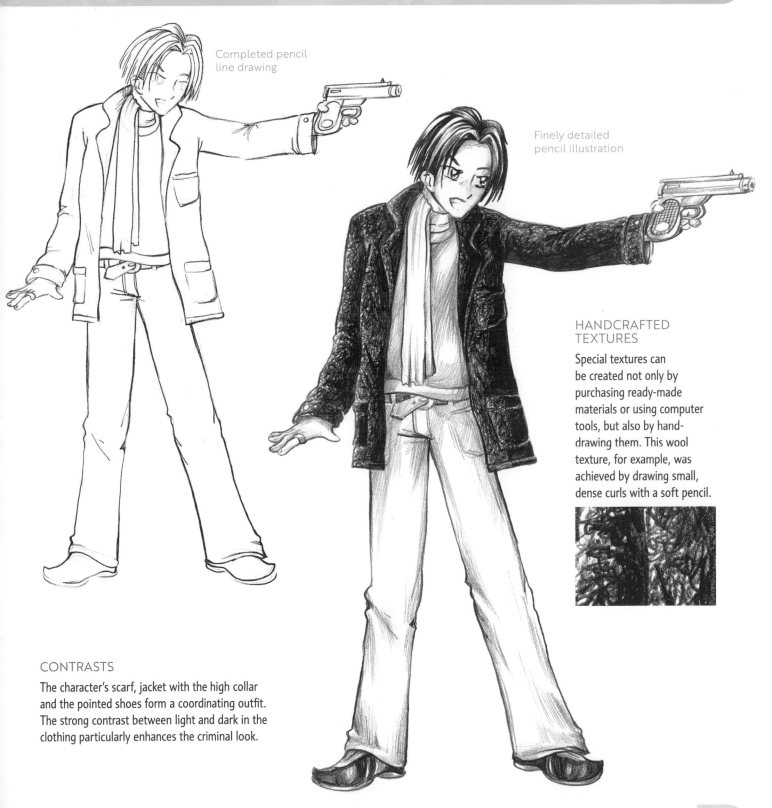

Completed pencil
line drawing

Finely detailed
pencil illustration

HANDCRAFTED TEXTURES

Special textures can
be created not only by
purchasing ready-made
materials or using computer
tools, but also by hand-
drawing them. This wool
texture, for example, was
achieved by drawing small,
dense curls with a soft pencil.

CONTRASTS

The character's scarf, jacket with the high collar
and the pointed shoes form a coordinating outfit.
The strong contrast between light and dark in the
clothing particularly enhances the criminal look.

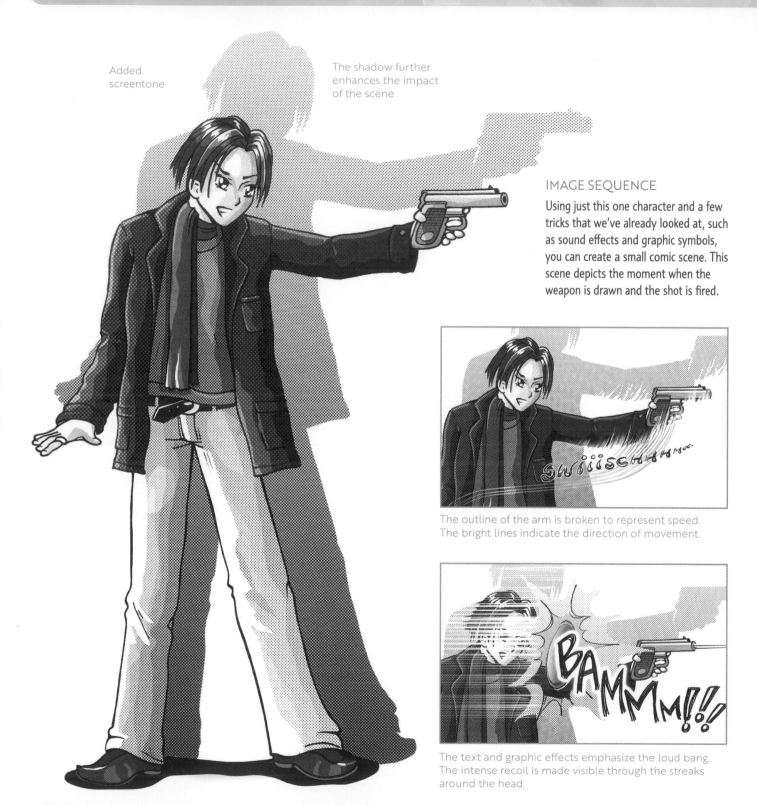

Added
screentone

The shadow further
enhances the impact
of the scene

IMAGE SEQUENCE

Using just this one character and a few
tricks that we've already looked at, such
as sound effects and graphic symbols,
you can create a small comic scene. This
scene depicts the moment when the
weapon is drawn and the shot is fired.

The outline of the arm is broken to represent speed.
The bright lines indicate the direction of movement.

The text and graphic effects emphasize the loud bang.
The intense recoil is made visible through the streaks
around the head.

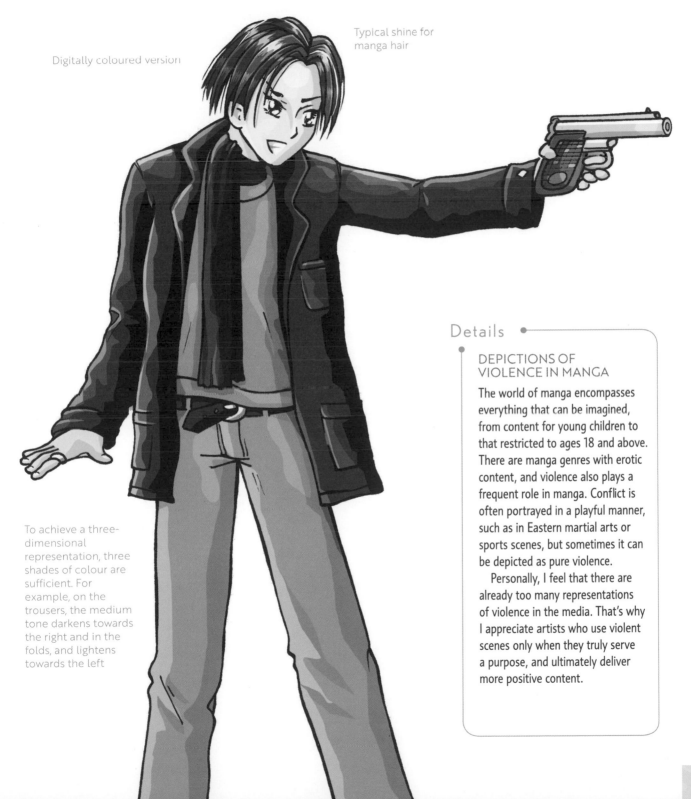

Digitally coloured version

Typical shine for manga hair

To achieve a three-dimensional representation, three shades of colour are sufficient. For example, on the trousers, the medium tone darkens towards the right and in the folds, and lightens towards the left

Details

DEPICTIONS OF VIOLENCE IN MANGA

The world of manga encompasses everything that can be imagined, from content for young children to that restricted to ages 18 and above. There are manga genres with erotic content, and violence also plays a frequent role in manga. Conflict is often portrayed in a playful manner, such as in Eastern martial arts or sports scenes, but sometimes it can be depicted as pure violence.

Personally, I feel that there are already too many representations of violence in the media. That's why I appreciate artists who use violent scenes only when they truly serve a purpose, and ultimately deliver more positive content.

Prima ballerina

In contrast to the action sports characters featured in the following pages, when drawing a ballerina, the focus is on a more subtle form of artistic expression.

This shojo ballerina should be as graceful as possible.

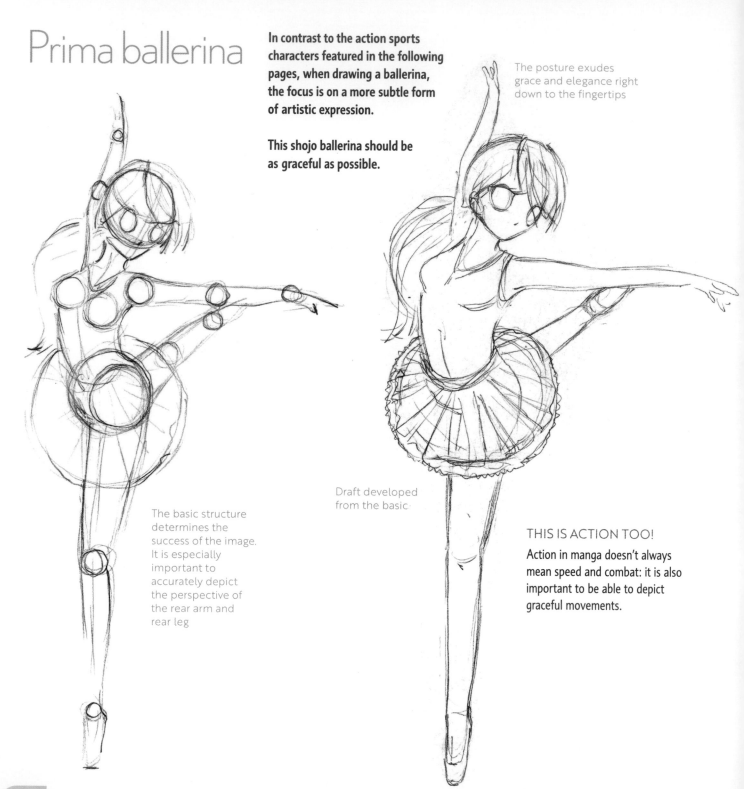

The posture exudes grace and elegance right down to the fingertips

The basic structure determines the success of the image. It is especially important to accurately depict the perspective of the rear arm and rear leg

Draft developed from the basic

THIS IS ACTION TOO!

Action in manga doesn't always mean speed and combat: it is also important to be able to depict graceful movements.

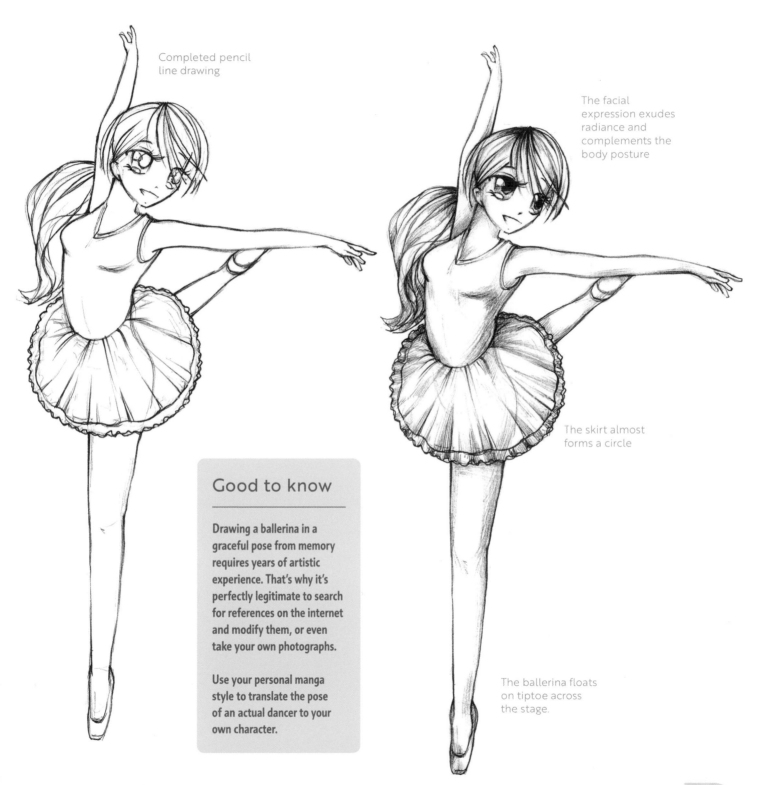

Completed pencil line drawing

The facial expression exudes radiance and complements the body posture

The skirt almost forms a circle

Good to know

Drawing a ballerina in a graceful pose from memory requires years of artistic experience. That's why it's perfectly legitimate to search for references on the internet and modify them, or even take your own photographs.

Use your personal manga style to translate the pose of an actual dancer to your own character.

The ballerina floats on tiptoe across the stage.

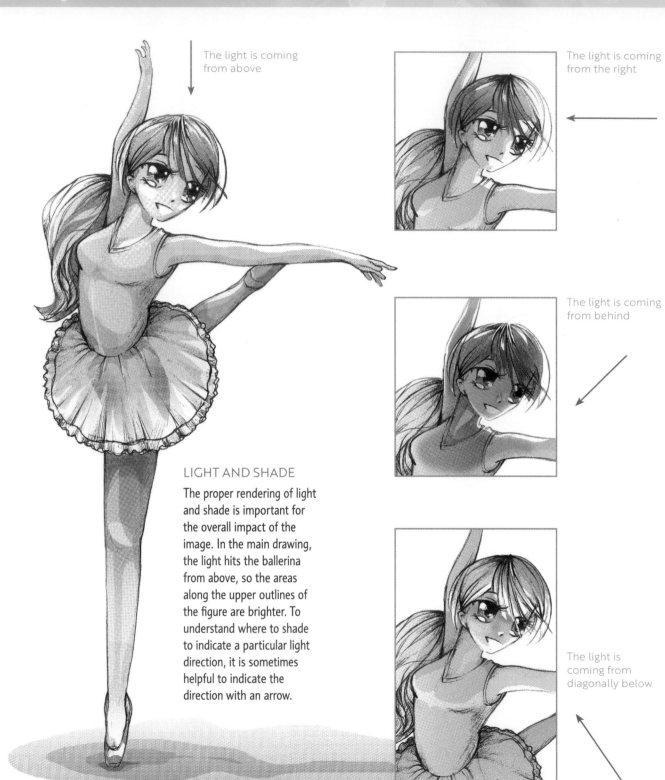

The light is coming from above

The light is coming from the right

The light is coming from behind

The light is coming from diagonally below

LIGHT AND SHADE

The proper rendering of light and shade is important for the overall impact of the image. In the main drawing, the light hits the ballerina from above, so the areas along the upper outlines of the figure are brighter. To understand where to shade to indicate a particular light direction, it is sometimes helpful to indicate the direction with an arrow.

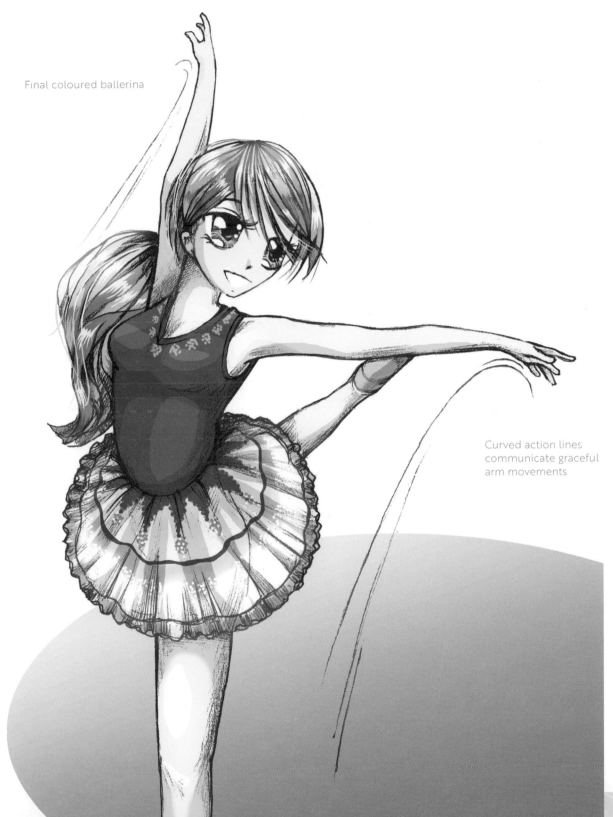

Final coloured ballerina

Curved action lines
communicate graceful
arm movements

Football star

Football is a popular manga theme. In Japan, there are manga volumes released daily that are solely dedicated to football matches. It's no wonder that the Japanese women's national soccer team is world-class, and the men's team is also on the right track.

As manga artists, for us football primarily means action!

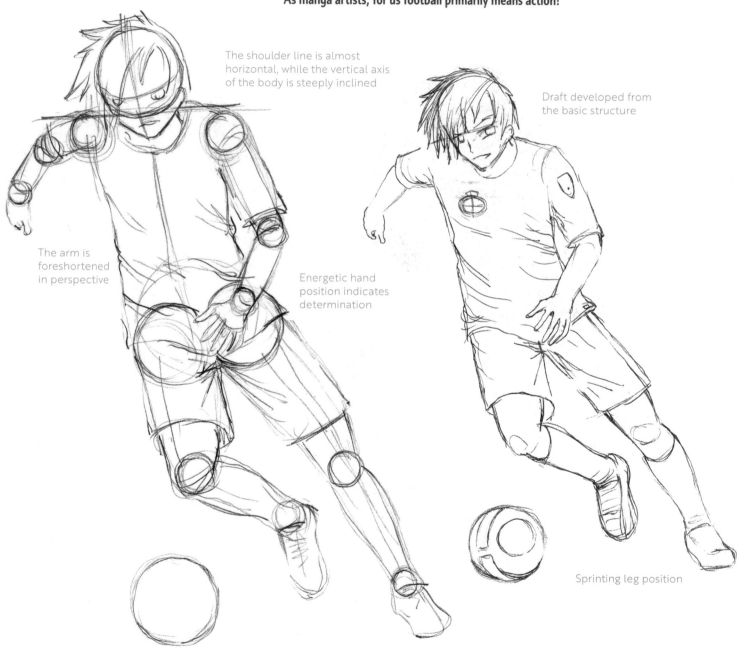

The shoulder line is almost horizontal, while the vertical axis of the body is steeply inclined

Draft developed from the basic structure

The arm is foreshortened in perspective

Energetic hand position indicates determination

Sprinting leg position

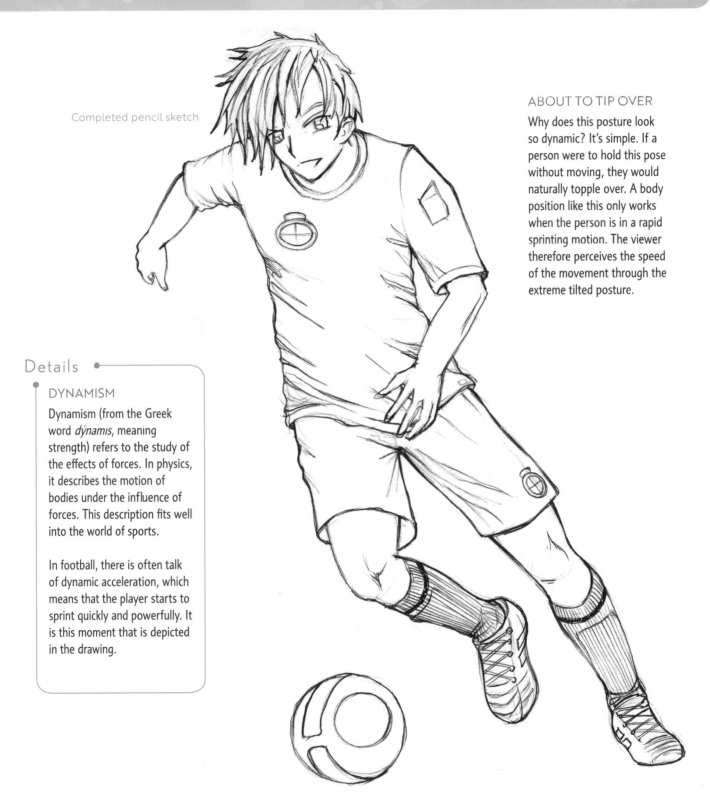

Completed pencil sketch

ABOUT TO TIP OVER

Why does this posture look so dynamic? It's simple. If a person were to hold this pose without moving, they would naturally topple over. A body position like this only works when the person is in a rapid sprinting motion. The viewer therefore perceives the speed of the movement through the extreme tilted posture.

Details

DYNAMISM

Dynamism (from the Greek word *dýnamis*, meaning strength) refers to the study of the effects of forces. In physics, it describes the motion of bodies under the influence of forces. This description fits well into the world of sports.

In football, there is often talk of dynamic acceleration, which means that the player starts to sprint quickly and powerfully. It is this moment that is depicted in the drawing.

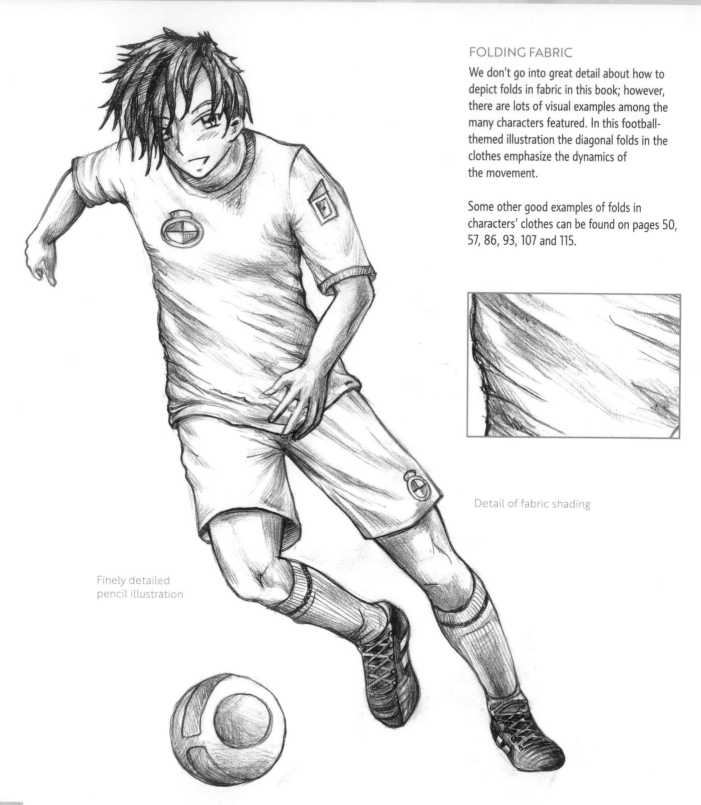

FOLDING FABRIC

We don't go into great detail about how to depict folds in fabric in this book; however, there are lots of visual examples among the many characters featured. In this football-themed illustration the diagonal folds in the clothes emphasize the dynamics of the movement.

Some other good examples of folds in characters' clothes can be found on pages 50, 57, 86, 93, 107 and 115.

Detail of fabric shading

Finely detailed pencil illustration

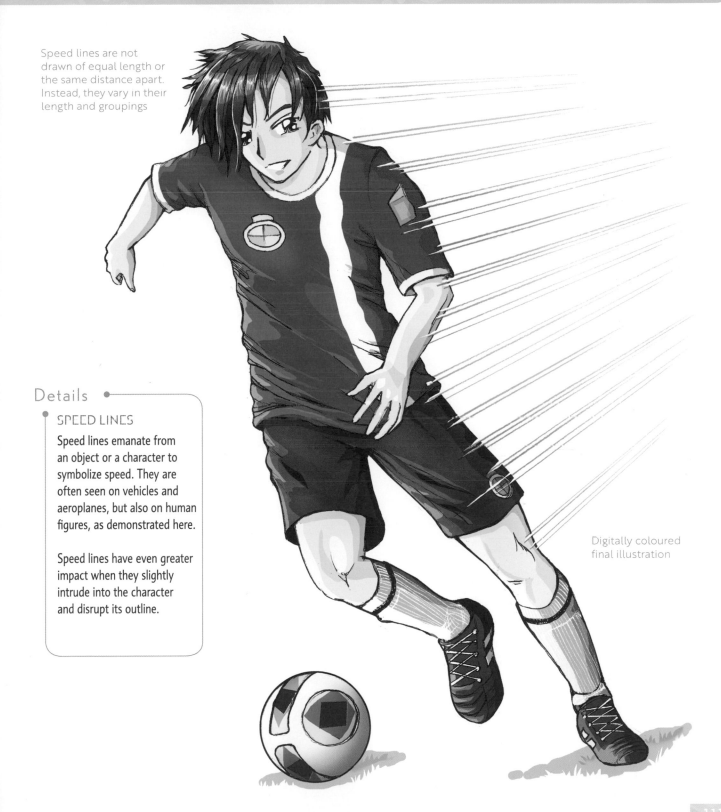

Speed lines are not drawn of equal length or the same distance apart. Instead, they vary in their length and groupings

Details

SPEED LINES

Speed lines emanate from an object or a character to symbolize speed. They are often seen on vehicles and aeroplanes, but also on human figures, as demonstrated here.

Speed lines have even greater impact when they slightly intrude into the character and disrupt its outline.

Digitally coloured final illustration

Basketball player

Basketball is another popular sports theme in manga. Although the sport doesn't receive as much coverage in European media compared with football, motorsports, boxing or tennis, it fits well within the manga context. This is primarily because basketball is a typical high-school sport, and most manga stories are set in school or high-school environments.

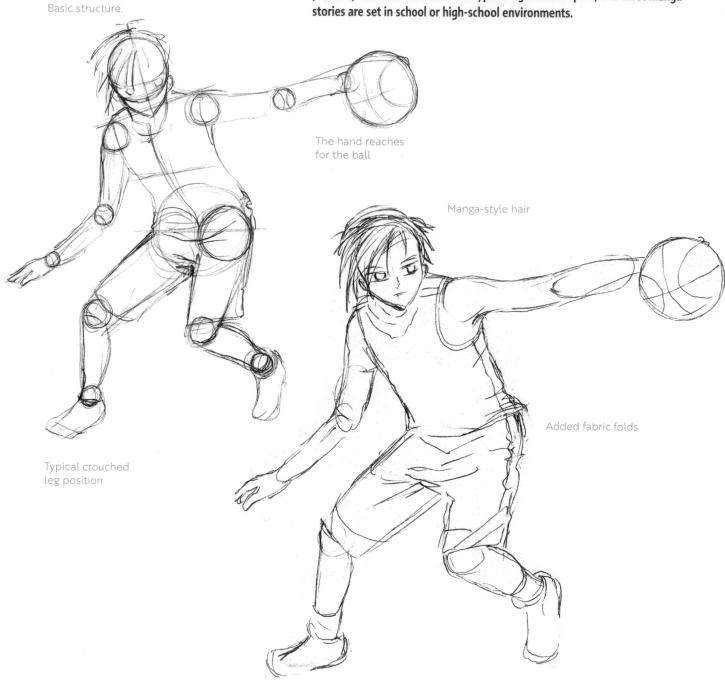

Basic structure.

The hand reaches for the ball

Manga-style hair

Typical crouched leg position

Added fabric folds

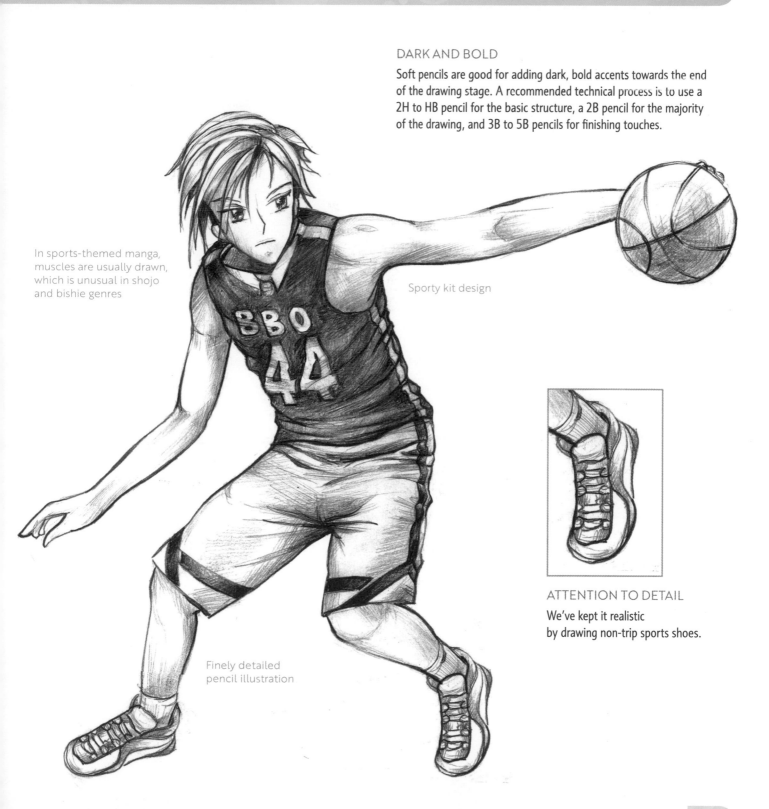

DARK AND BOLD

Soft pencils are good for adding dark, bold accents towards the end of the drawing stage. A recommended technical process is to use a 2H to HB pencil for the basic structure, a 2B pencil for the majority of the drawing, and 3B to 5B pencils for finishing touches.

In sports-themed manga, muscles are usually drawn, which is unusual in shojo and bishie genres

Sporty kit design

BBO 44

Finely detailed pencil illustration

ATTENTION TO DETAIL

We've kept it realistic by drawing non-trip sports shoes.

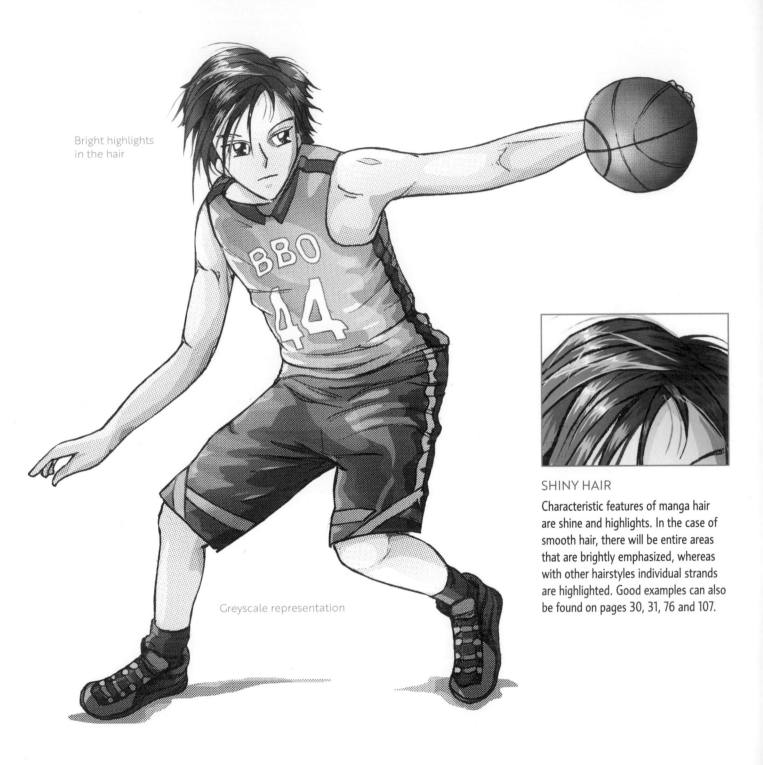

Bright highlights
in the hair

Greyscale representation

SHINY HAIR

Characteristic features of manga hair
are shine and highlights. In the case of
smooth hair, there will be entire areas
that are brightly emphasized, whereas
with other hairstyles individual strands
are highlighted. Good examples can also
be found on pages 30, 31, 76 and 107.

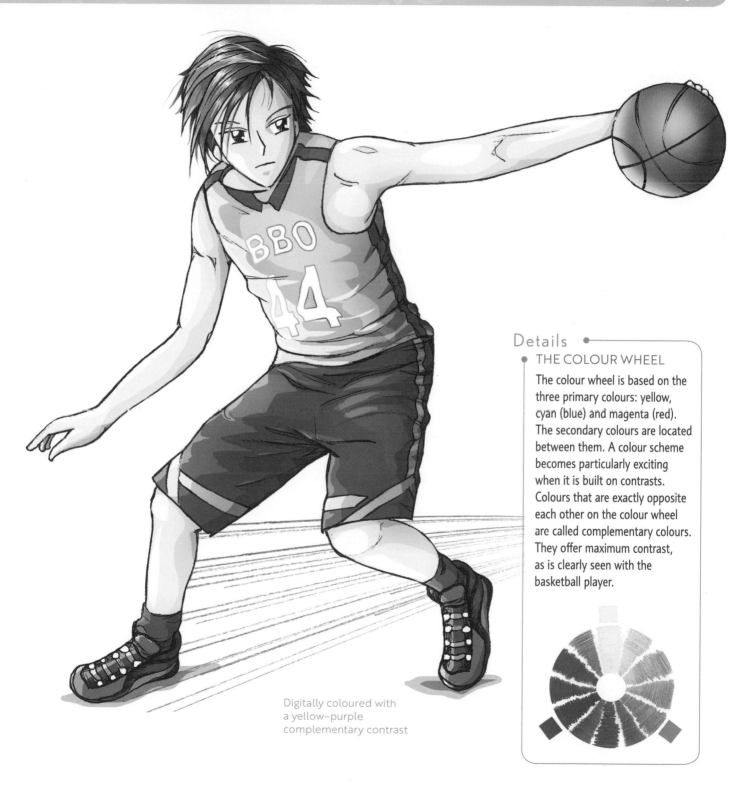

Digitally coloured with
a yellow–purple
complementary contrast

Details

THE COLOUR WHEEL

The colour wheel is based on the
three primary colours: yellow,
cyan (blue) and magenta (red).
The secondary colours are located
between them. A colour scheme
becomes particularly exciting
when it is built on contrasts.
Colours that are exactly opposite
each other on the colour wheel
are called complementary colours.
They offer maximum contrast,
as is clearly seen with the
basketball player.

A manga story is born

Now's the time! You are ready to develop a complete manga story. Emotions, body language, expressive eyes, unique outfits, backgrounds and action – these are the elements that make a good manga story. But there's one thing missing: the narrative itself. Here's a brief guide on how to create a concept for your manga novel.

THE TEXT CONCEPT

As you have done with the visuals, you also need to create the concept for the storyline, which means the text. The written summary of a story with all the important characters, locations and scenes is called the plot, while the later version with the exact wording is known as the script. Some artists prefer to first write the complete story and then start drawing, while others immediately draw and write the text directly into the draft of the illustrations. Each author and artist needs to find the approach that works best for them.

Thumbnails are quickly drawn sketches

Thumbnails are small-format sketches that help the author to conceptualize their complete story before moving on to the actual drawings. Thumbnails can be even smaller than those shown here!

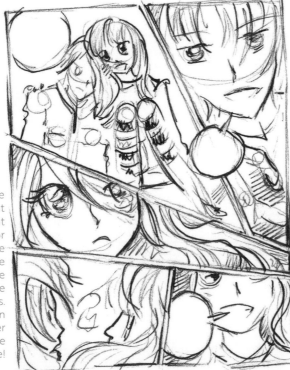

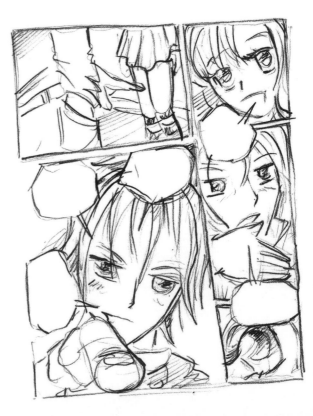

LAYOUT VARIATIONS

The shape of individual panels and their arrangement on the page determine whether a story looks exciting or not, which is why layout variations are crucial.

Simplified layout

Special layout forms with different image formats and varying borders

SPEECH BUBBLES

Speech or thought bubbles are another crucial design element. Just as with image formats, there are various shapes for speech bubbles. Some are rounded, others are square; some are vertical, while others are wide. The artist is effectively the director of the scene and decides on their shape.

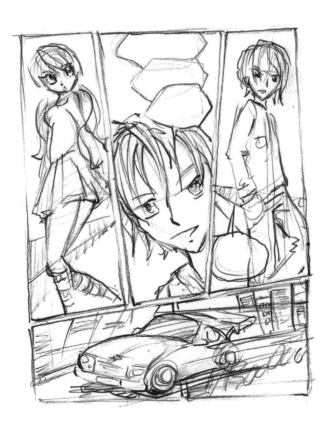 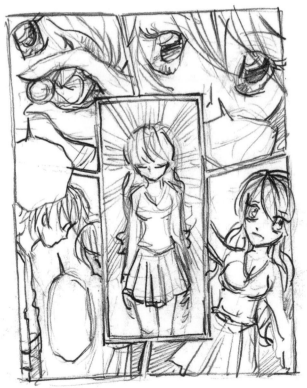

Thumbnails help the artist to figure out the shape and size of speech and thought bubbles

117

PANELS

Panels are the layouts of individual pages in a manga book. In this example, they have been sketched in detail, ready to be finalized with ink, or digitally.

STYLISTIC ELEMENTS

Important stylistic elements to make a manga story exciting include:

» Varied panel formats
» Speech bubbles that extend beyond the panel borders
» Zoom effects, showing close-up and distant depictions, such as faces
» Unconventional framing and composition
» A balanced ratio of text to image size
» Bringing the focus back to the characters' eyes
» Conveying the intense emotions of the main characters.

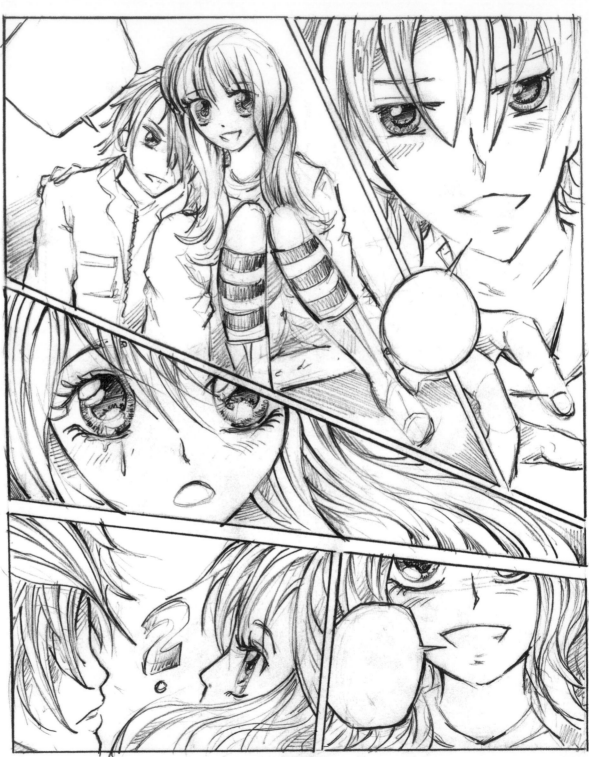

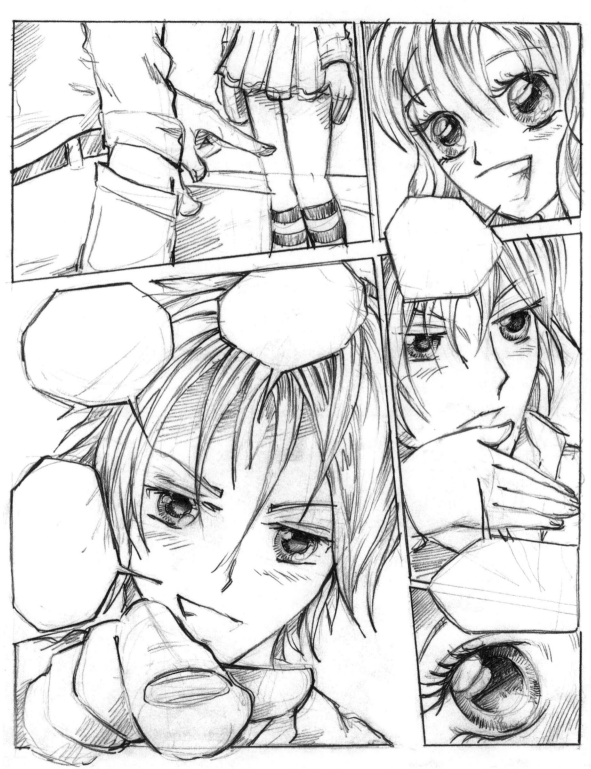

READING DIRECTION

Traditionalists still prefer the Japanese way of creating manga, which means that books are read from back to front and the pages from right to left, which may be unconventional for European readers. Nevertheless, even in Japan, manga is now published by artists from different backgrounds. Art always reflects the changing times, and those who embrace influences from other artists, regardless of their origin, can find inspiration in them.

Characters and style

Essentially, we are now at the end of the book, because what else could come
after creating our own manga, right? But no! This is where it truly begins. The
manga scene constantly brings forth new creative inspirations and techniques.
We embrace ideas and develop our own life philosophies from them.

This chapter explores stylistic variations such as shonen and anthros, as well
as the influences of and on art and society. Punk, emo, goth or cosplay are
just four examples that demonstrate how art, culture and world view mutually
influence each other in changing times.

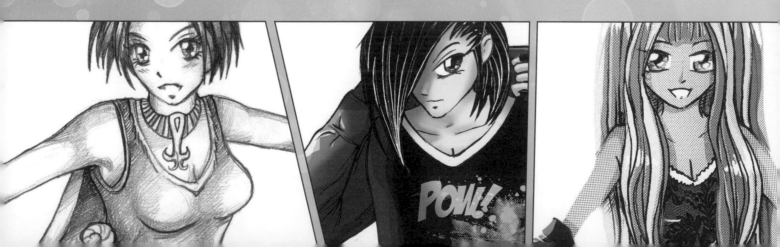

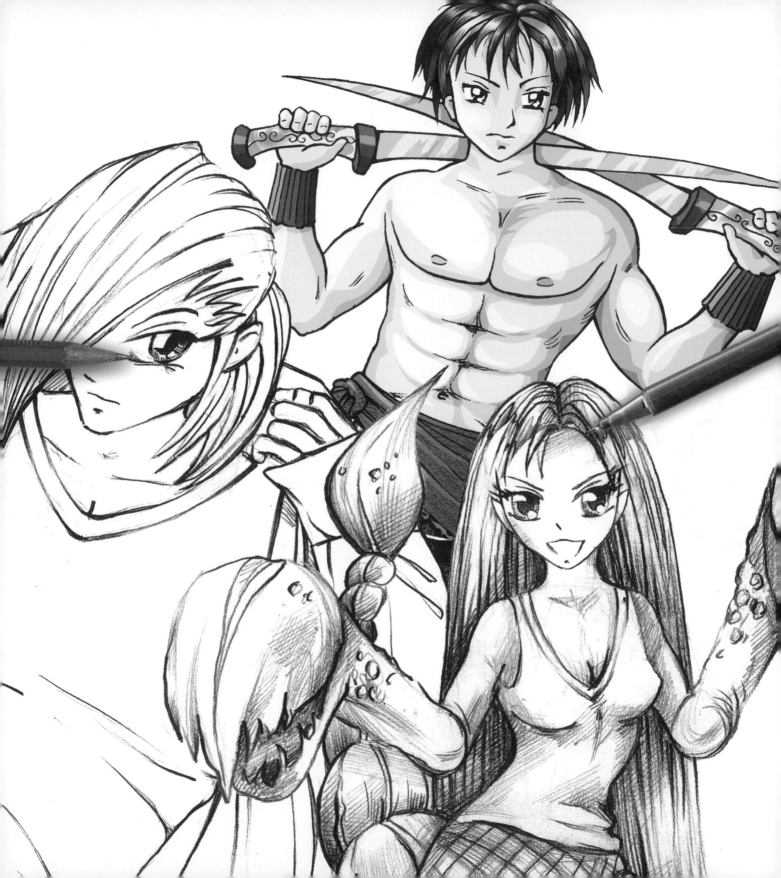

Scorpion woman

Anthro in manga art refers to a specific design form where human and animal elements are combined in one character. The term anthropomorphism (Greek: *anthropos* for human and *morph* for form, shape) refers to the giving of human characteristics to animals, gods, natural forces and similar entities. Typically, the characters have the shape of animals with human elements, but it can also be the other way around.

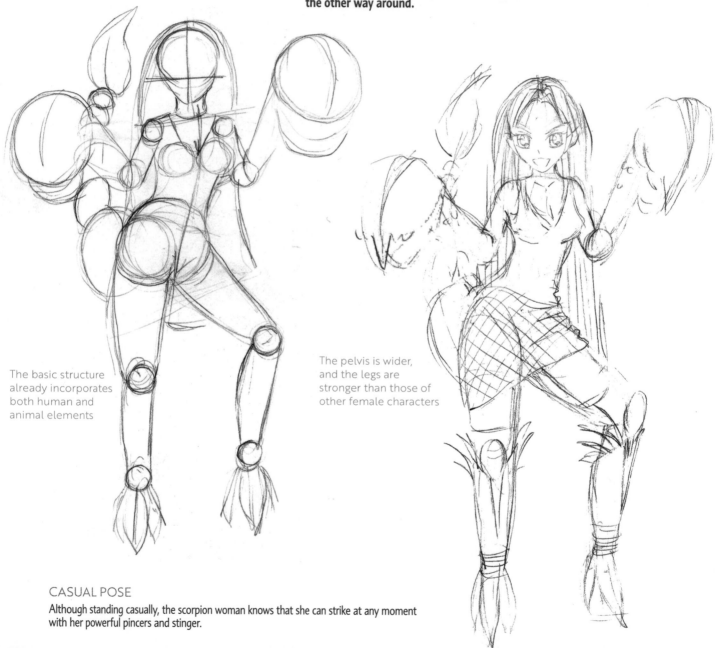

The basic structure already incorporates both human and animal elements

The pelvis is wider, and the legs are stronger than those of other female characters

CASUAL POSE
Although standing casually, the scorpion woman knows that she can strike at any moment with her powerful pincers and stinger.

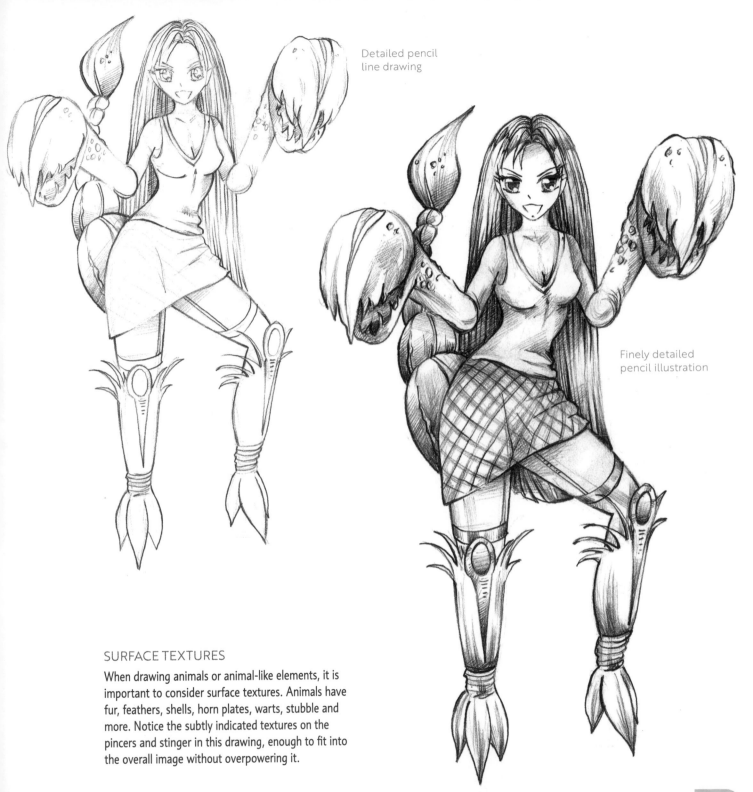

Detailed pencil
line drawing

Finely detailed
pencil illustration

SURFACE TEXTURES

When drawing animals or animal-like elements, it is
important to consider surface textures. Animals have
fur, feathers, shells, horn plates, warts, stubble and
more. Notice the subtly indicated textures on the
pincers and stinger in this drawing, enough to fit into
the overall image without overpowering it.

Cat girl

Not all anthros are menacing. There are also examples of the exact opposite, featuring humanized animals with cute faces and a gentle character. Animals that move gracefully or with agility lend themselves particularly well to such transformations.

This example of a cat girl exudes anything but a threatening vibe.

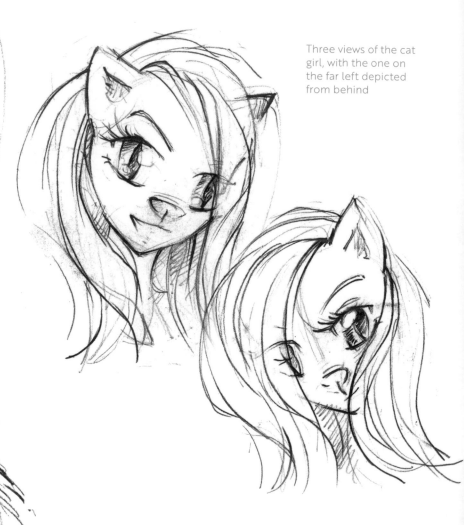

Three views of the cat girl, with the one on the far left depicted from behind

SKETCH SHEETS

To remind you of the process of developing a manga character, these two pages exclusively showcase studies of the cat girl. The final design emerges through the production of multiple sketch sheets and variations of the character.

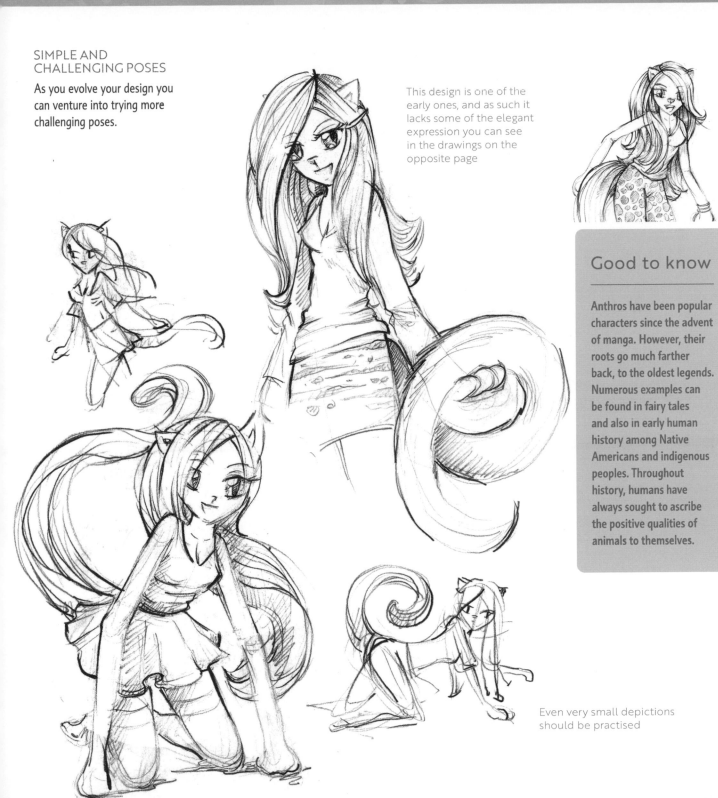

SIMPLE AND CHALLENGING POSES

As you evolve your design you can venture into trying more challenging poses.

This design is one of the early ones, and as such it lacks some of the elegant expression you can see in the drawings on the opposite page

Good to know

Anthros have been popular characters since the advent of manga. However, their roots go much farther back, to the oldest legends. Numerous examples can be found in fairy tales and also in early human history among Native Americans and indigenous peoples. Throughout history, humans have always sought to ascribe the positive qualities of animals to themselves.

Even very small depictions should be practised

Vampire

The myth of the undead creatures who feed on human blood resurfaces time and again, in movies, animated films and books. Manga also frequently features vampire stories, since the vampire realm is a perfect platform for love and emotions infused with horror. However, vampires no longer only inhabit abandoned castles; they are among us at work, at school, in our sports teams and beyond.

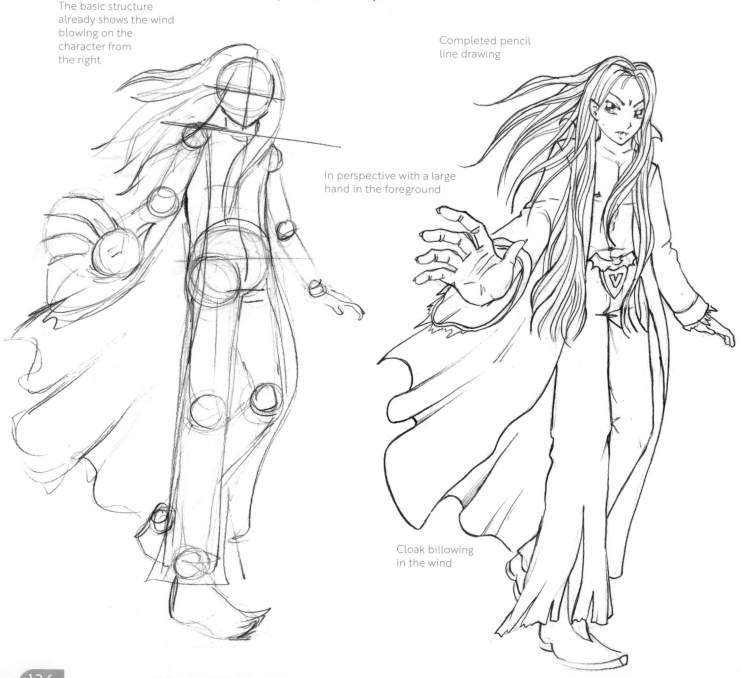

The basic structure already shows the wind blowing on the character from the right

Completed pencil line drawing

In perspective with a large hand in the foreground

Cloak billowing in the wind

Details

THE GOTH SCENE

There isn't a direct connection between vampires and the goth scene, yet there are noticeable parallels. The black clothing, the interest in night and death, and the pale skin are typical in both cases. Similarly, there is a rejection of traditional religious life, which is manifested in vampires recoiling at the sight of a Christian cross. So, those who draw vampires can find abundant inspiration in the goth subculture.

HATCHING

To enhance the depiction of wind, the hatching lines on the cloak are aligned in the direction of the wind, and drawn quickly and dynamically.

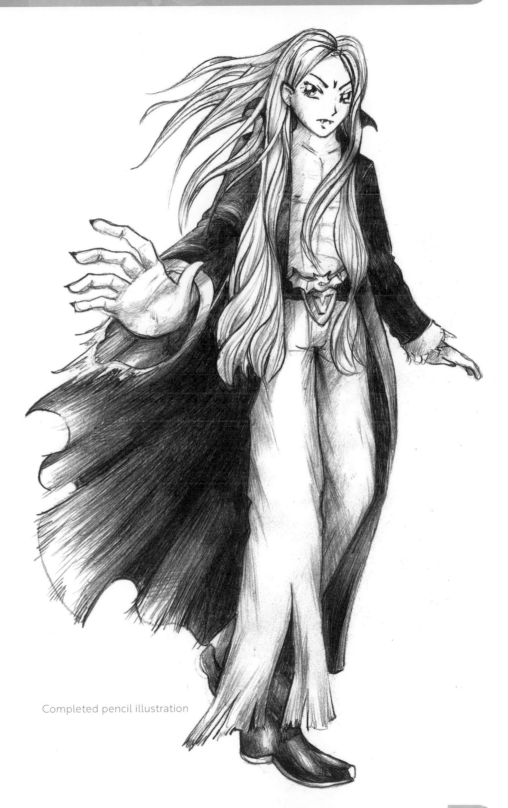

Completed pencil illustration

Sci-fi hero

Basic structure with axes added to the face, shoulders and hips

Shonen (also spelled shounen) is the manga genre in which adventure heroes take the lead. The depictions can vary greatly, including martial artists, monsters, teenage heroes and science-fiction or fantasy characters. Some of the characters featured in this chapter – the young gun, football star and basketball player – fit into this genre in a broader sense.

On these two pages, a female hero is featured to expand on the theme.

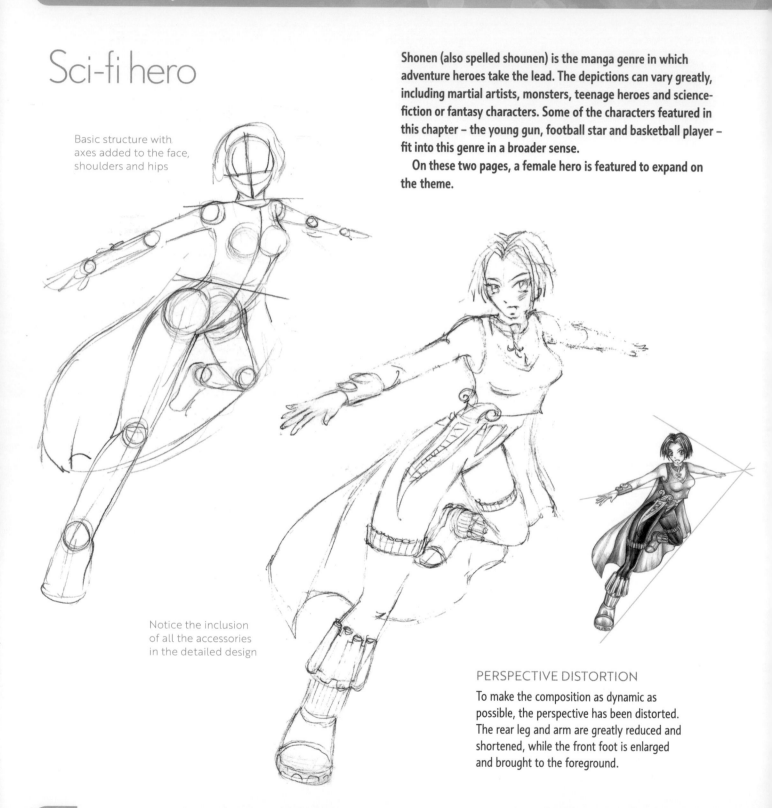

Notice the inclusion of all the accessories in the detailed design

PERSPECTIVE DISTORTION

To make the composition as dynamic as possible, the perspective has been distorted. The rear leg and arm are greatly reduced and shortened, while the front foot is enlarged and brought to the foreground.

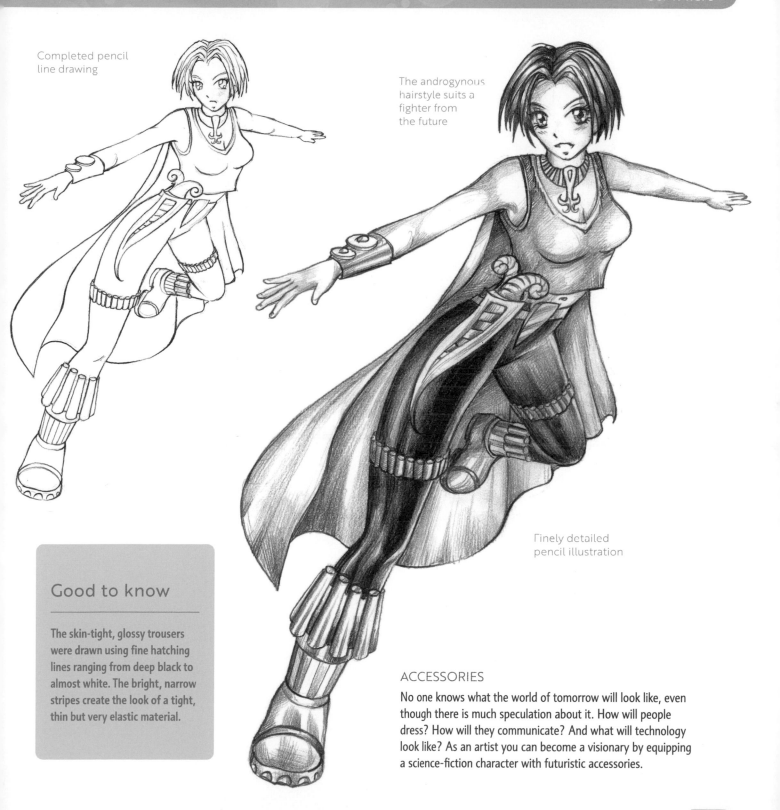

Completed pencil line drawing

The androgynous hairstyle suits a fighter from the future

Finely detailed pencil illustration

Good to know

The skin-tight, glossy trousers were drawn using fine hatching lines ranging from deep black to almost white. The bright, narrow stripes create the look of a tight, thin but very elastic material.

ACCESSORIES

No one knows what the world of tomorrow will look like, even though there is much speculation about it. How will people dress? How will they communicate? And what will technology look like? As an artist you can become a visionary by equipping a science-fiction character with futuristic accessories.

Young fighter

Young fighters from the Far East who use swords in combat are probably one of the most common motifs in manga history. However, in illustrating such characters it's not only about the action of the fight itself, but also about presenting the body and well-toned muscles.

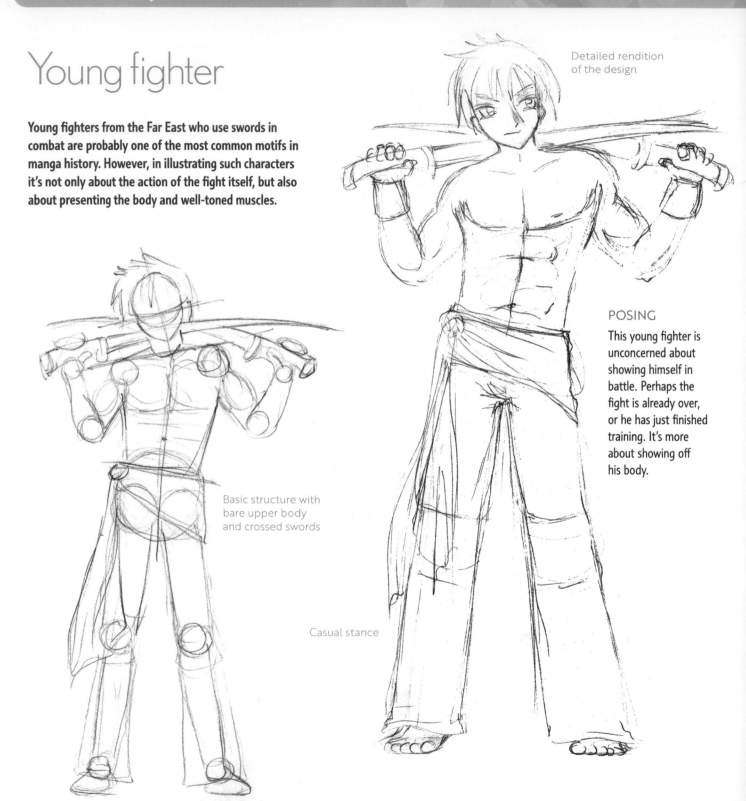

Detailed rendition of the design

Basic structure with bare upper body and crossed swords

Casual stance

POSING

This young fighter is unconcerned about showing himself in battle. Perhaps the fight is already over, or he has just finished training. It's more about showing off his body.

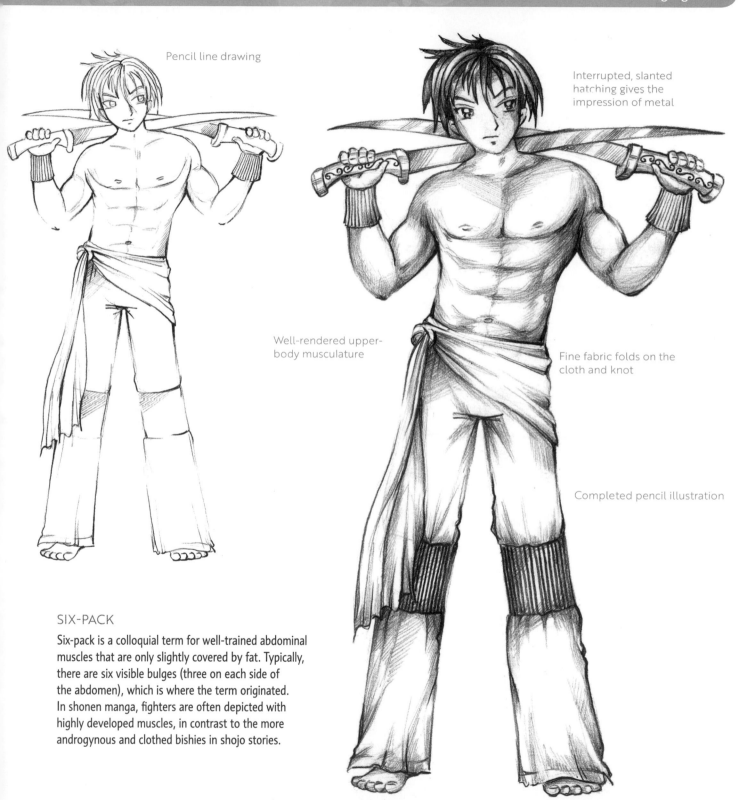

Pencil line drawing

Interrupted, slanted hatching gives the impression of metal

Well-rendered upper-body musculature

Fine fabric folds on the cloth and knot

Completed pencil illustration

SIX-PACK

Six-pack is a colloquial term for well-trained abdominal muscles that are only slightly covered by fat. Typically, there are six visible bulges (three on each side of the abdomen), which is where the term originated. In shonen manga, fighters are often depicted with highly developed muscles, in contrast to the more androgynous and clothed bishies in shojo stories.

Details

BODY IMAGE

In manga art the human body is often depicted in idealized ways, as can be seen with this young fighter.

Female characters are usually slim, with long legs and pronounced feminine forms. This impression is often further supported by clothing, consisting of short skirts and tight tops.

When it comes to boys, there are two different interpretations: the well-trained fighters and the fashion-conscious, introverted bishies.

You can, of course, play with this concept for your own characters, perhaps making them more realistic in body shape, or going the opposite way and escaping reality by exaggerating notions of 'ideal' body shapes.

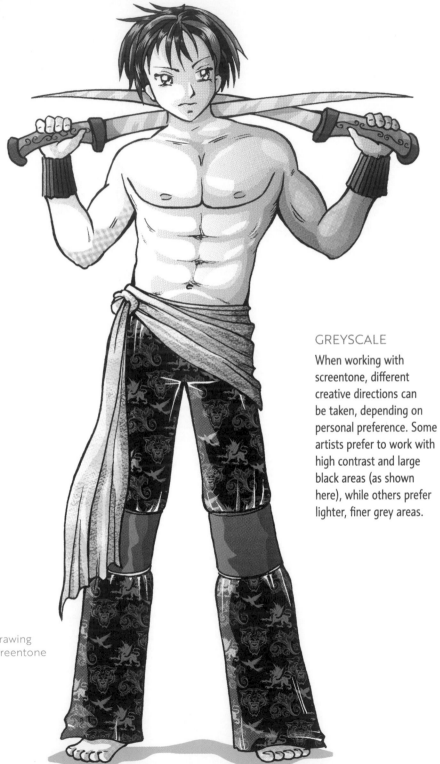

GREYSCALE

When working with screentone, different creative directions can be taken, depending on personal preference. Some artists prefer to work with high contrast and large black areas (as shown here), while others prefer lighter, finer grey areas.

Final drawing with screentone

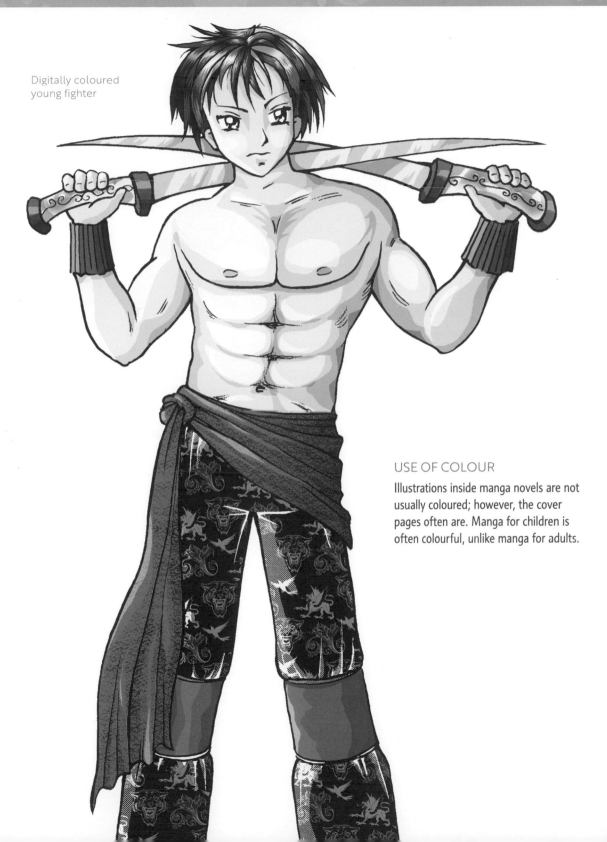

Digitally coloured
young fighter

USE OF COLOUR

Illustrations inside manga novels are not
usually coloured; however, the cover
pages often are. Manga for children is
often colourful, unlike manga for adults.

Dark teen boy

In the previous chapter we discussed bishies, the slender, sensitive and fashion-conscious counterparts to shojo characters. Over the next four pages, we'll create a character that aligns with bishie ideals but also incorporates other aspects. This character exhibits distinct features of various youth cultures that have developed in recent years, or even decades, as well as encompassing manga-style characteristics.

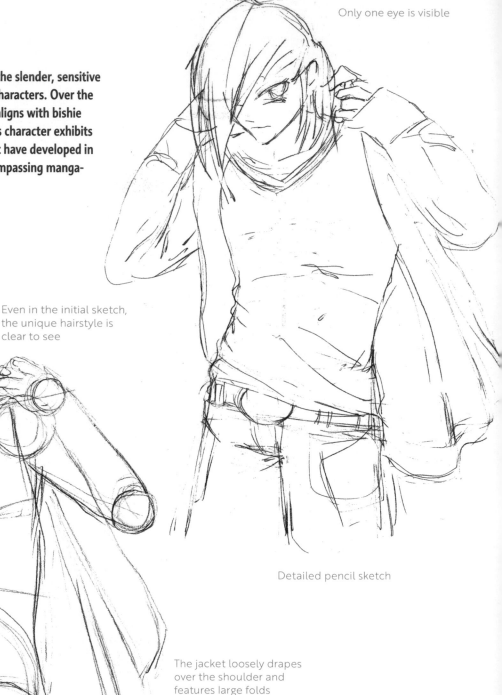

Only one eye is visible

Even in the initial sketch, the unique hairstyle is clear to see

Detailed pencil sketch

The jacket loosely drapes over the shoulder and features large folds

HIDDEN FACE

Covering the face – and even one eye – with hair was fashionable in the 1970s and 1980s among the New Wave and New Romantic youth cultures, and is popular with emos to this day. Veiling the face signifies turning away from the outside world, and extreme hairstyles have long been worn to provoke the conventional and hypocritical adult world. Manga artists reflect such societal trends in their art, and youth cultures are influenced in return by manga art.

The look presents the boy as an introverted rebel.

The focus is entirely on the one eye

Graphics software often includes extensive libraries of images, such as the skull depicted here, which can be easily incorporated into your own designs

Pencil line drawing

Details

YOUTH CULTURES

Youth culture refers to the activities and fashion styles of teenagers within a shared scene. The teenagers are looking to establish their own subculture within an existing adult culture – an adult culture that is often despised by the youth, because it does not provide satisfying means of expression for their philosophies of life. These youth cultures are reflected in manga drawing as the fashion and social trends influence the design process of the artists.

SMOOTH COLOUR FIELDS

Smooth colour fields without gradations or shadows have their charms, as seen in this illustration. Sometimes, increasing the level of detail may not necessarily improve the drawing.

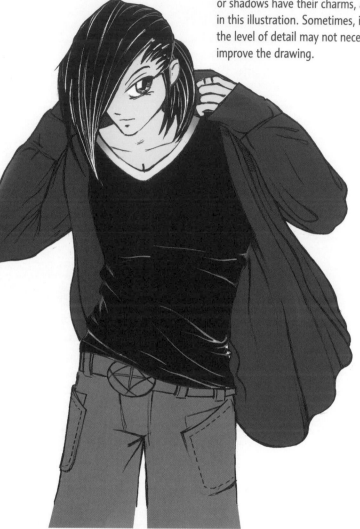

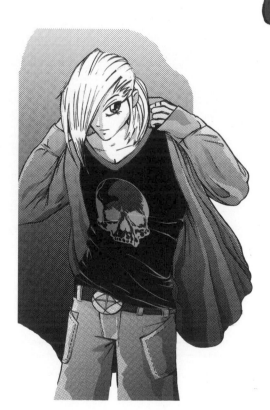

Version with fair hair

WHITE OUTLINES

Completely blacked-out areas are common in manga art, which means that the black outlines are no longer visible. An easy trick for addressing this is to outline those areas with white.

Digitally coloured illustration

This modified T-shirt design is also sourced from a graphics database

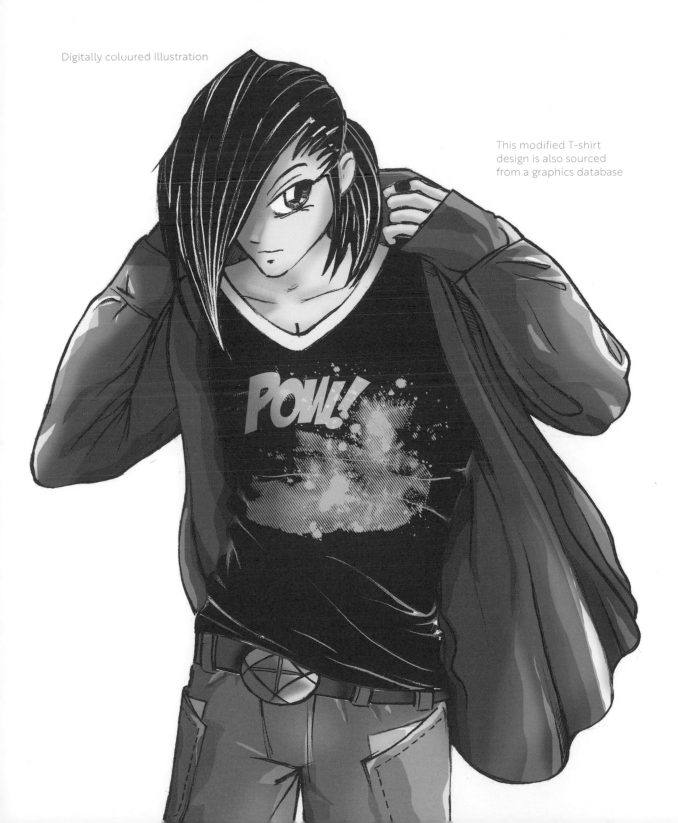

Dark teen girl

This girl is friends with the dark teen boy on the previous pages. It's not difficult to imagine them together in a story. They might be a couple, just friends or even siblings fighting for a cause.

Perhaps you have your own ideas for an exciting story using these two characters together?

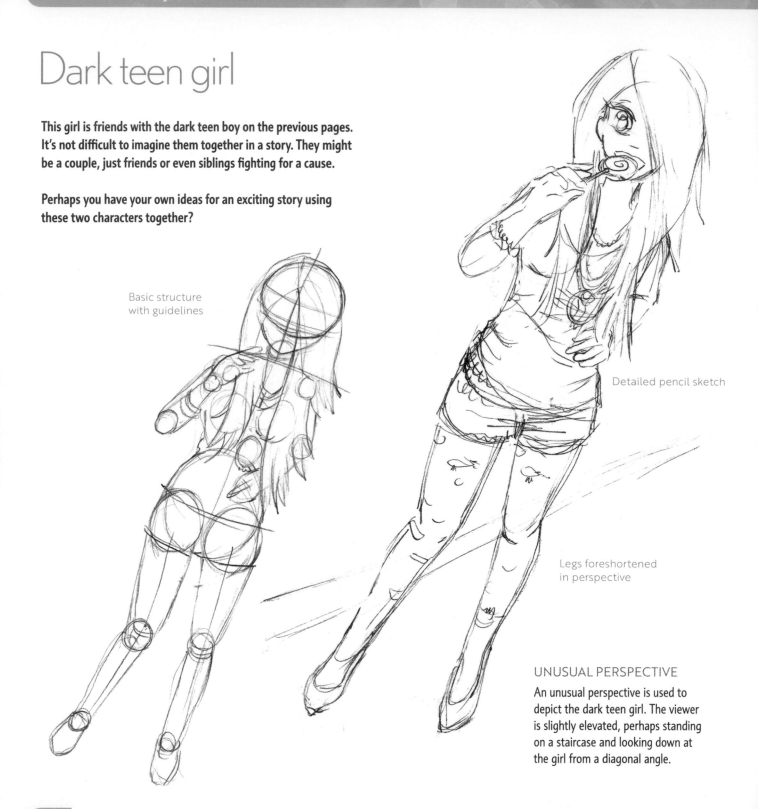

Basic structure with guidelines

Detailed pencil sketch

Legs foreshortened in perspective

UNUSUAL PERSPECTIVE

An unusual perspective is used to depict the dark teen girl. The viewer is slightly elevated, perhaps standing on a staircase and looking down at the girl from a diagonal angle.

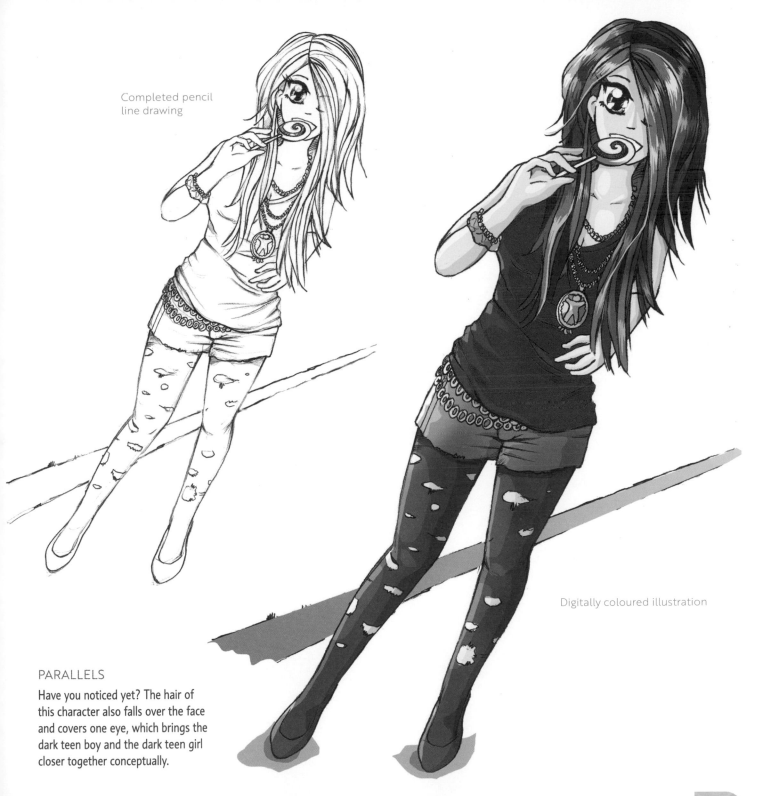

Completed pencil
line drawing

Digitally coloured illustration

PARALLELS

Have you noticed yet? The hair of
this character also falls over the face
and covers one eye, which brings the
dark teen boy and the dark teen girl
closer together conceptually.

Cosplay

This drawing was inspired by a girl who had herself photographed in the costume of a manga character. The concept of people taking their cues from drawings and dressing up as manga characters has been reversed here, with the character drawn as if wearing a costume.

Basic structure

UNUSUAL POSE

The pose of the character is of particular interest in this drawing, since the body and arms form a cross. Poses like this one always carry an air of mystery and magic, probably due to their religious connotations.

Details

WHAT IS COSPLAY?

Cosplay is a manga costume trend that originated in Japan and spread to Europe and the United States in the 1990s. Cosplay participants portray characters from manga, anime, video games or films, in terms of costume and behaviour.

Anyone that has been to a manga convention knows how incredibly beautiful and meticulously crafted these costumes can be. Fabrics are carefully chosen and sewn, and make-up is artfully applied.

Detailed pencil sketch

Screentone can be used to create patterns on clothing

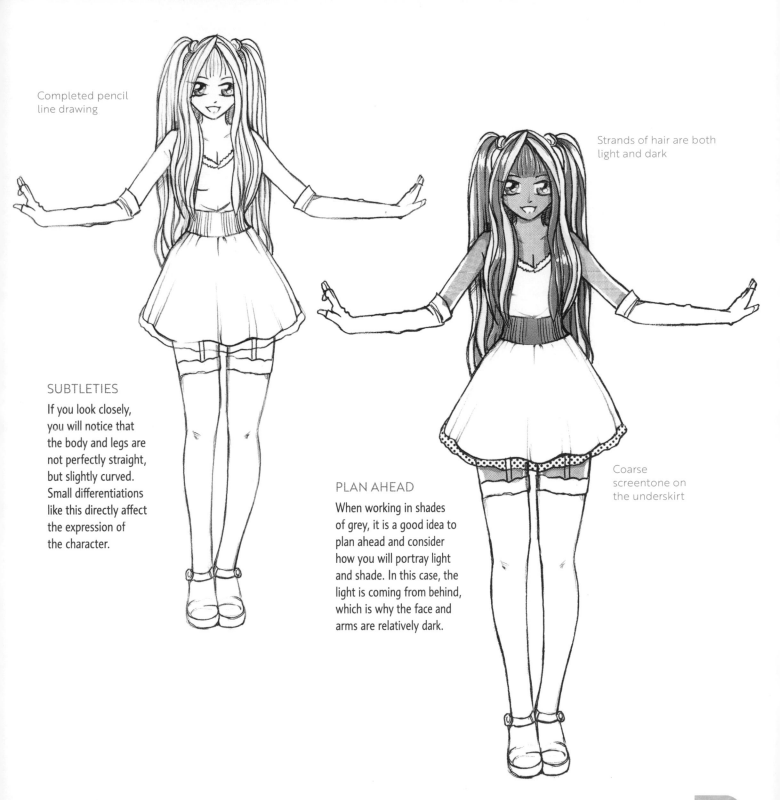

Completed pencil line drawing

Strands of hair are both light and dark

SUBTLETIES

If you look closely, you will notice that the body and legs are not perfectly straight, but slightly curved. Small differentiations like this directly affect the expression of the character.

PLAN AHEAD

When working in shades of grey, it is a good idea to plan ahead and consider how you will portray light and shade. In this case, the light is coming from behind, which is why the face and arms are relatively dark.

Coarse screentone on the underskirt

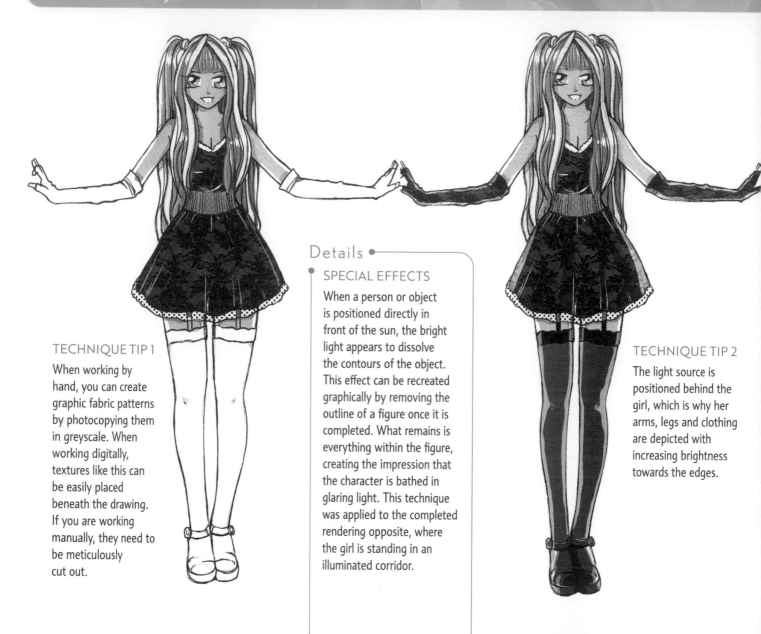

Details

SPECIAL EFFECTS

When a person or object is positioned directly in front of the sun, the bright light appears to dissolve the contours of the object. This effect can be recreated graphically by removing the outline of a figure once it is completed. What remains is everything within the figure, creating the impression that the character is bathed in glaring light. This technique was applied to the completed rendering opposite, where the girl is standing in an illuminated corridor.

TECHNIQUE TIP 1

When working by hand, you can create graphic fabric patterns by photocopying them in greyscale. When working digitally, textures like this can be easily placed beneath the drawing. If you are working manually, they need to be meticulously cut out.

TECHNIQUE TIP 2

The light source is positioned behind the girl, which is why her arms, legs and clothing are depicted with increasing brightness towards the edges.

Erased outline

Black outline

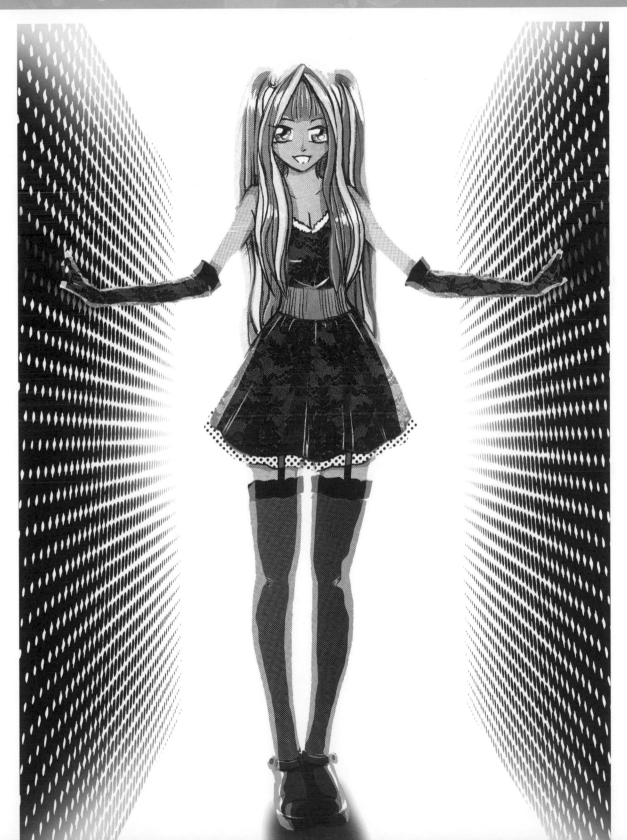

First published in Great Britain 2024
by Search Press Limited
Wellwood, North Farm Road,
Tunbridge Wells, Kent TN2 3DR

The original German edition was published as *Manga Step by Step*
Copyright © 2016 frechverlag GmbH, Stuttgart, Germany (www.topp-kreativ.de)
This edition is published by arrangement with Anja Endemann, AE Rights Agency, Berlin, Germany

English translation by Burravoe Translation Services

PHOTOGRAPHY: frechverlag GmbH, Turbinenstr. 7, 70499 Stuttgart; © fotolia (bokeh background:
adam 121); Gerhard Wörner, Stuttgart (all other images)
CONCEPT AND PRODUCT MANAGEMENT: Hannelore Irmer-Romeo
ORIGINAL EDITING: Nicole Mering, Nottuln
LAYOUT: DOPPELPUNKT, Stuttgart
COVER DESIGN: Nakischa Scheibe
ORIGINAL TYPESETTING: Gerhard Wörner

ISBN: 978-1-80092-173-3
ebook ISBN: 978-1-80093-153-4

Suppliers
If you have difficulty in obtaining any of the materials and equipment mentioned in this book, then please
visit the Search Press website for details of suppliers: www.searchpress.com

Bookmarked Hub
For further ideas and inspiration, and to join our free online community, visit www.bookmarkedhub.com

You are invited to follow the author on:
Facebook: @GeckoKeckBooksArtsDesign • @GeckoKeckGraphicArt • @geckomanga
Instagram: @gecko_keck_secret_map • @geckomanga/channel

FSC
www.fsc.org

MIX
Paper | Supporting
responsible forestry
FSC® C020056